HOW TO DRAW MANGA
BISHOUJO
❀Pretty Gals

Table of Contents

HOW TO DRAW MANGA: BISHOUJO – Pretty Gals
by Hikaru Hayashi, Go Office

Copyright © 1999 Hikaru Hayashi, Go Office
Copyright © 1999 Graphic-sha Publishing Co., Ltd.

First published in 1999 by Graphic-sha Publishing Co., Ltd.
This English edition was published in 2000 by Graphic-sha Publishing Co., Ltd.
1-9-12 Kudan-kita, Chiyoda-ku, Tokyo, 102-0073 Japan

Planning & Production: Yasuo Matsumoto, Kento Shimazaki, Kazuaki Morita, Takehiko Matsumoto,
Kimiko Morimoto, Riho Yagizawa, Ganma Suzuki, Tomo Otomo, Kiyoe Yokoyama
Cover drawing: Eimu Mizuki
Cover Coloring: Takashi Nakagawa
Reference work: Eimu Mizuki, Kouichi Kusano, Kaoru Kawakata, Tomoko Taniguchi,
Mako Sakura, Ganma Suzuki
Composition: Akira Hayashi (Go Office)
English Cover design: Shinichi Ishioka
English edition layout: Shinichi Ishioka
English translation: Christian Storms
English translation management: Língua fránca, Inc. (an3y-skmt@asahi-net.or.jp)
Japanese edition editor: Motofumi Nakanishi (Graphic-sha Publishing Co., Ltd.)
Foreign language edition project coordinator: Kumiko Sakamoto (Graphic-sha Publishing Co., Ltd.)

Distributed by
NIPPAN IPS CO., LTD.
11-6, 3 Chome, Iidabashi,
Chiyoda-ku, Tokyo
102-0072, Japan
Tel: +81-(0)3-3238-0676
Fax: +81-(0)3-3238-0996
E-mail: ips03@nippan-ips.co.jp

Distributed Exclusively
in North America by
DIGITAL MANGA DISTRIBUTION
1123 Dominguez St., Unite "K"
Carson, CA 90746, U.S.A.
Tel: (310) 604-9701
Fax: (310) 604-1134
E-mail: distribution@emanga.com
URL:http://www.emanga.com/dmd/

First printing: November 2000
Second printing: May 2001
Third printing: August 2001

ISBN: 4-7661-1148-6
Printed and bound in China by Everbest Printing Co., Ltd.

Chapter 1

BISHOUJO Character Drawing Theory

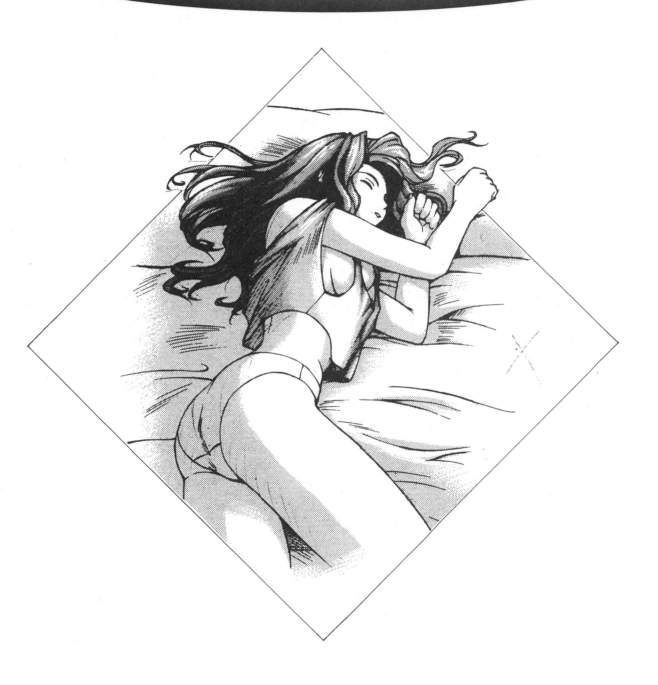

Grasping the Key Traits of BISHOUJO Characters

The variations of BISHOUJO characters are endless. Try your best to master the key characteristics of the various types.

The Girls Next Door

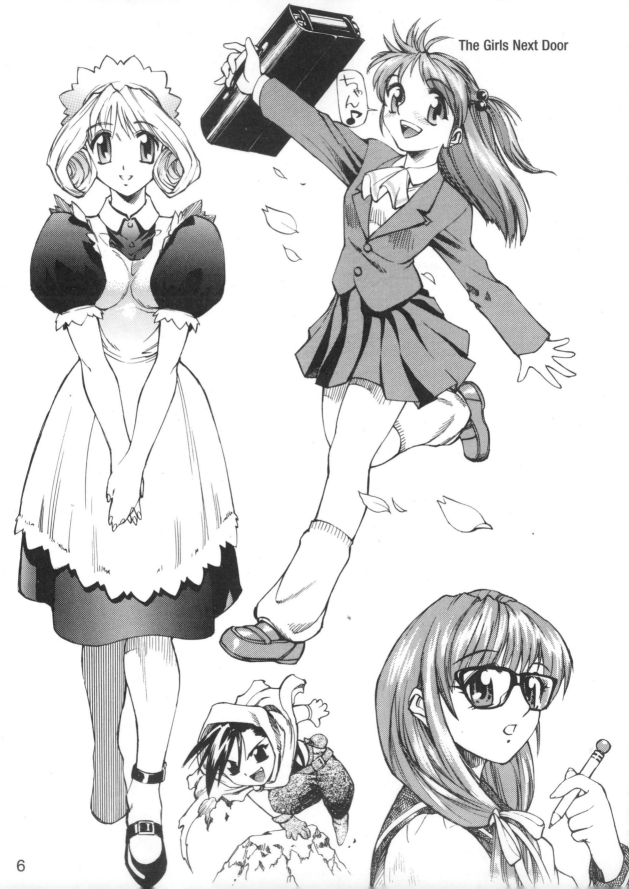

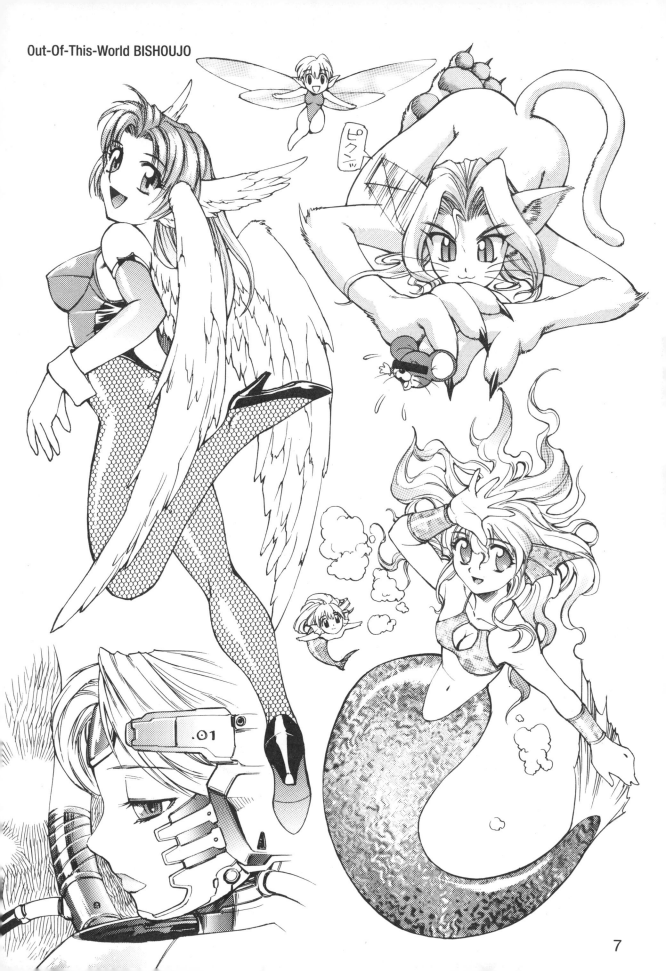

The cross '+' marked in the face acts as balance lines for the face and as a guideline when drawing the position of eyes, noses, etc.

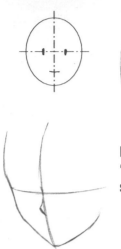

Draw a cross '+' inside a suitable circle.

Along the vertical line, align the tip of the chin with the bottom of the nose.

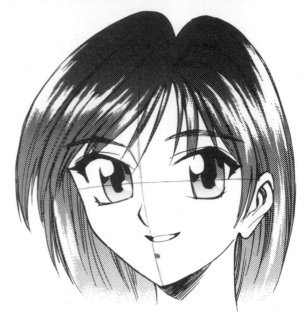

The face is ordinarily drawn along these centerlines.

Vertical Lines

The vertical centerline serves to determine the overall balance of the face as well as the mood.

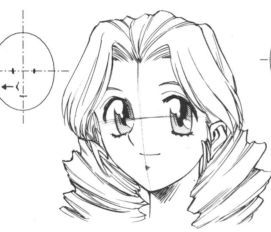

Shifting the position of the nose brings out a soft mood.

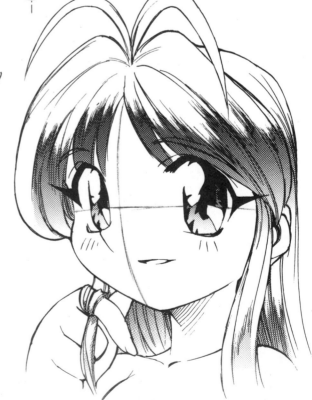

Shifting the position of the mouth brings out a delicate expression.

It is easy to bring out the gusto of character idiosyncrasies by shifting position of the nose and chin from the center position of the mouth in your designs.

The horizontal centerline is the key for determining the position of the eyes and ears.

Horizontal Lines

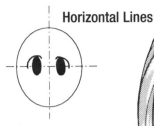

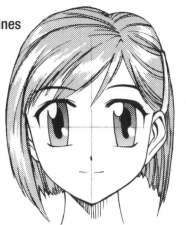

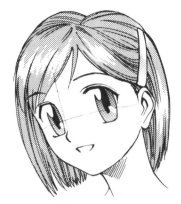

Big eyes placed along the centerline

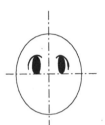

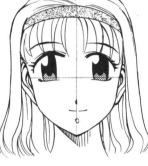

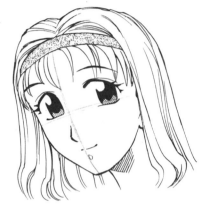

Big eyes placed slightly above the centerline

Looks more like a grown-up

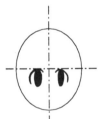

Big eyes placed slightly below the centerline

Looks more like a child

Distinctions Between Adult and Children's Faces

Be aware that some people believe that adult faces are not BISHOUJO faces.

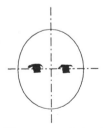

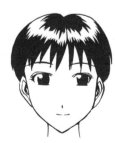

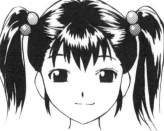

When normal sized eyes are drawn along the centerline:

To create adult faces:
- reduce the volume of the hair
- widen the distance between the eyes and nose

To create children's faces:
- increase the volume of the hair
- shorten the distance between the eyes and nose

Use the Japanese hiragana character for 'shi' — し as an image for drawing jaws on slanted faces.

For round jaws

For sharp jaws

Follow these steps:

1. Draw the jaw.

2. Draw the head.

3. Draw the eyes and nose.

The key is to draw the neck on the inside of the jaw.

The neck looks thick when drawn outside of the jaw.

The line from the ear towards the chin is called the 'jawline'. Hair also serves the purpose of correcting the jawline.

The lines on the face are the same as the lines on a skull. These lines express the connections between the chin and throat/neck ('chinline') and the chin and ears (jawline).

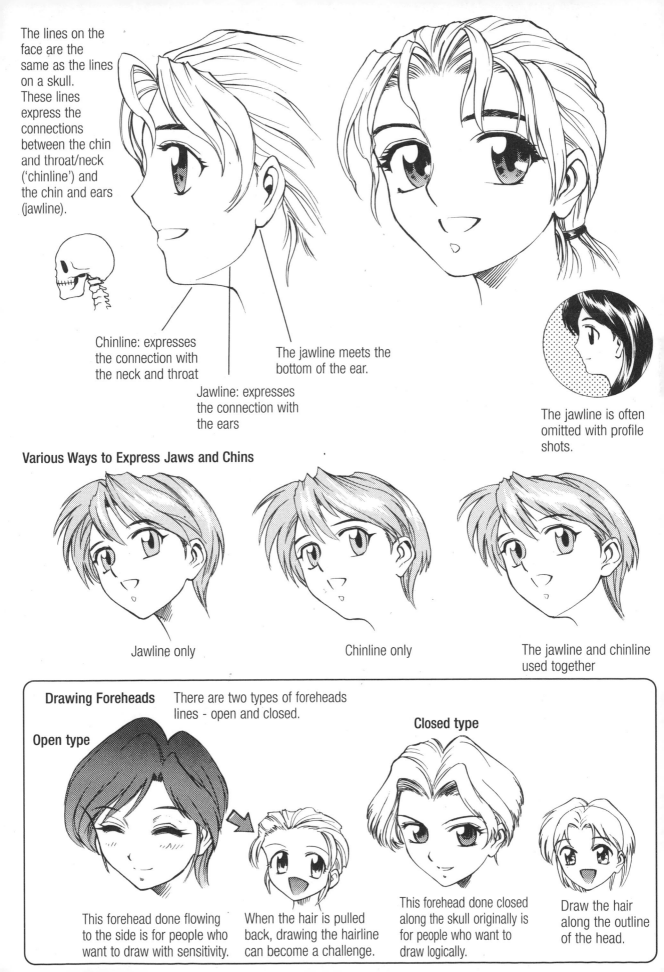

Chinline: expresses the connection with the neck and throat

Jawline: expresses the connection with the ears

The jawline meets the bottom of the ear.

The jawline is often omitted with profile shots.

Various Ways to Express Jaws and Chins

Jawline only

Chinline only

The jawline and chinline used together

Drawing Foreheads There are two types of foreheads lines - open and closed.

Open type

Closed type

This forehead done flowing to the side is for people who want to draw with sensitivity.

When the hair is pulled back, drawing the hairline can become a challenge.

This forehead done closed along the skull originally is for people who want to draw logically.

Draw the hair along the outline of the head.

Outlines and Facial Direction

The outline as well as the shape of the eyes and nose will change depending on the angle of the face, but draw what you like and try not to get caught up in theory too much.

Realistic Style

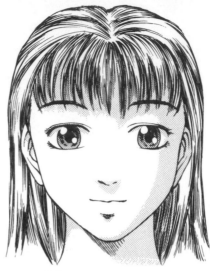

When drawing girls with large eyes, the eyes should be wide and slanted.

At times, the nose is not drawn even when expressing realism.

Manga Design Style

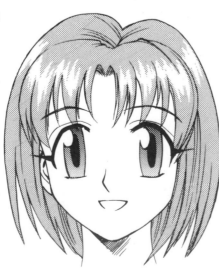

Here the eyes are big and the shape of the skull is not taken into consideration.

Even if the direction of the head changes, the shape of the nose can be handled with about two variations.

Sensitive Style

Despite the frontal view, the facial outline and the nose are given a slightly sideways look.

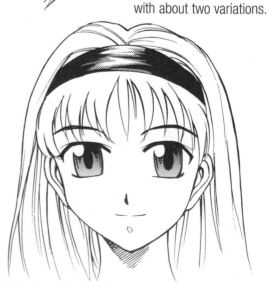

12

Aside from the facial outline (sideways), the nose and eyes of this type faces forward.

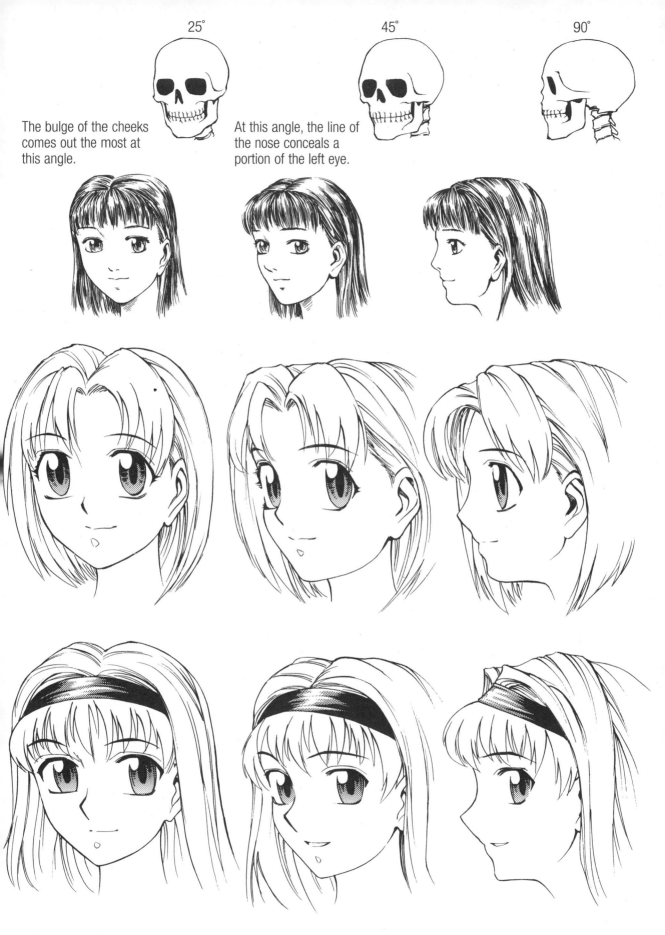

25°

45°

90°

The bulge of the cheeks comes out the most at this angle.

At this angle, the line of the nose conceals a portion of the left eye.

The eyeball and the upper and lower eyelids manifest eye expressions. A countless number of characters can be brought to life with the eyelids and the way the irises are drawn.

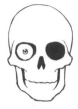

Eyeballs are essentially the same for people all over the world.

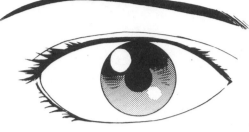

Normal eyes

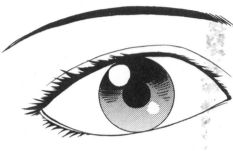

Droopy eyes

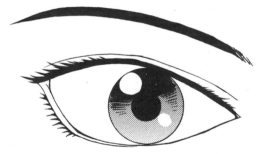

Raised eyes

Eye Structure

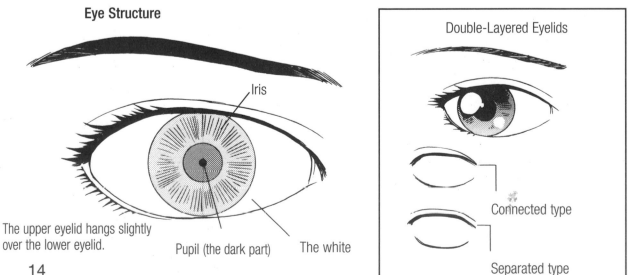

Iris

The upper eyelid hangs slightly over the lower eyelid.

Pupil (the dark part)

The white

Double-Layered Eyelids

Connected type

Separated type

Eye Types, Eyelashes and Eyebrows

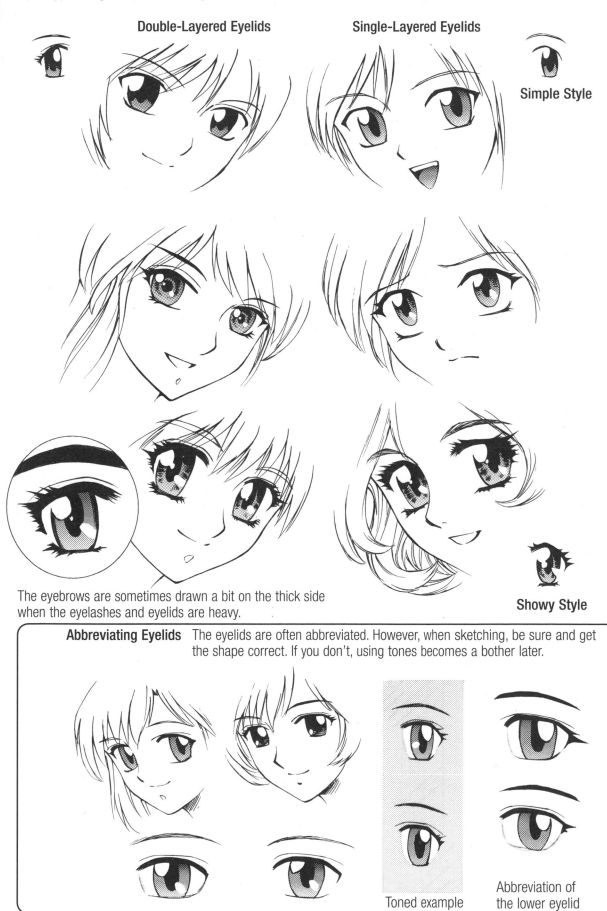

Double-Layered Eyelids

Single-Layered Eyelids

Simple Style

Showy Style

The eyebrows are sometimes drawn a bit on the thick side when the eyelashes and eyelids are heavy.

Abbreviating Eyelids The eyelids are often abbreviated. However, when sketching, be sure and get the shape correct. If you don't, using tones becomes a bother later.

Toned example

Abbreviation of the lower eyelid

How to Draw Eyes

It has been said that popularity of a certain manga can vary based on whether or not the eyes are appealing. Even the pros spend time researching how to make cute and appealing eyes.

There are two shapes of irises: round, ◯ and oval, ◯ .

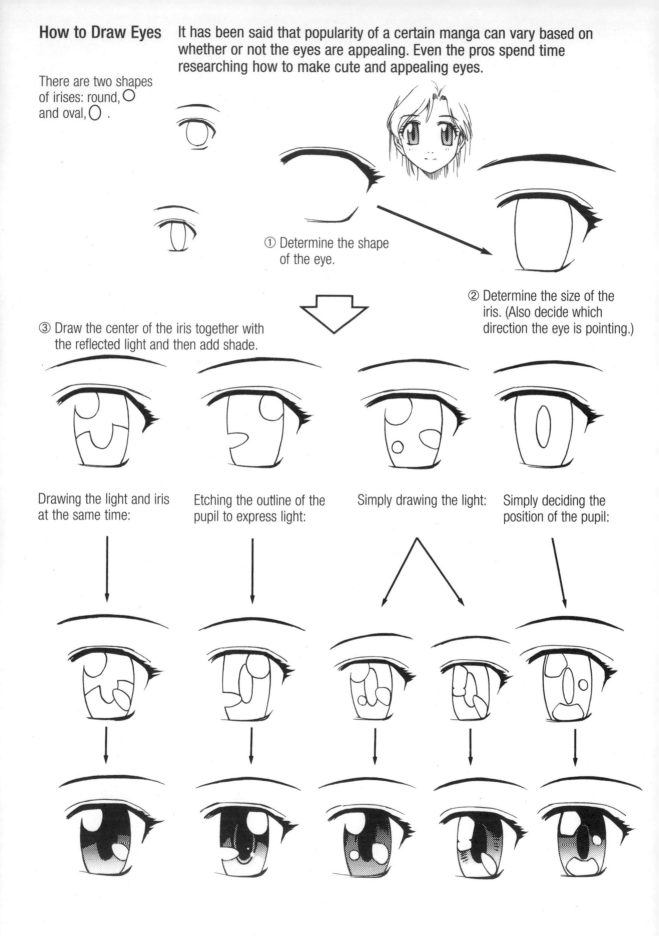

① Determine the shape of the eye.

② Determine the size of the iris. (Also decide which direction the eye is pointing.)

③ Draw the center of the iris together with the reflected light and then add shade.

Drawing the light and iris at the same time:

Etching the outline of the pupil to express light:

Simply drawing the light:

Simply deciding the position of the pupil:

Managing Various Irises

Eyes facing forward with large irises are said to be the basic eye style for popular characters.

Having even a little white area often labels characters as harsh or cold.

Various Irises Sizes

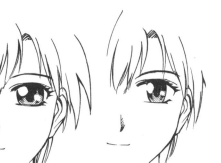

Dark-eyed type (percentage of blackness is 80% or more) → Light-eyed type (percentage of blackness is 30% or less)

A character's psychological state goes hand in hand with the expression of the irises.

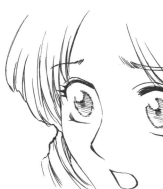

Shift lines

Outline only

Light outline only

OH, MY GOD!

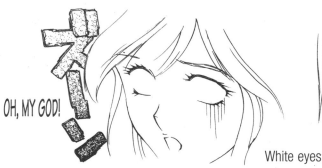

White eyes

Draw the iris on the small side when darkening the whites of the eyes.

Darkening the Whites of the Eyes — Out-Of-This-World Girls

Using black

Normal

Using tones

Gradation and double-pass shifts

Mixing black and gray while adding in light creates three-dimensionality while bringing about an eerie sense of life.

Use double-pass shifts for gradating the outline.

Shutting the Eyes

The wrinkles change when eyes are quietly shut or when closed tightly. In addition, the eyeline is a bit lower than the center position of the eyes when the eyes are shut.

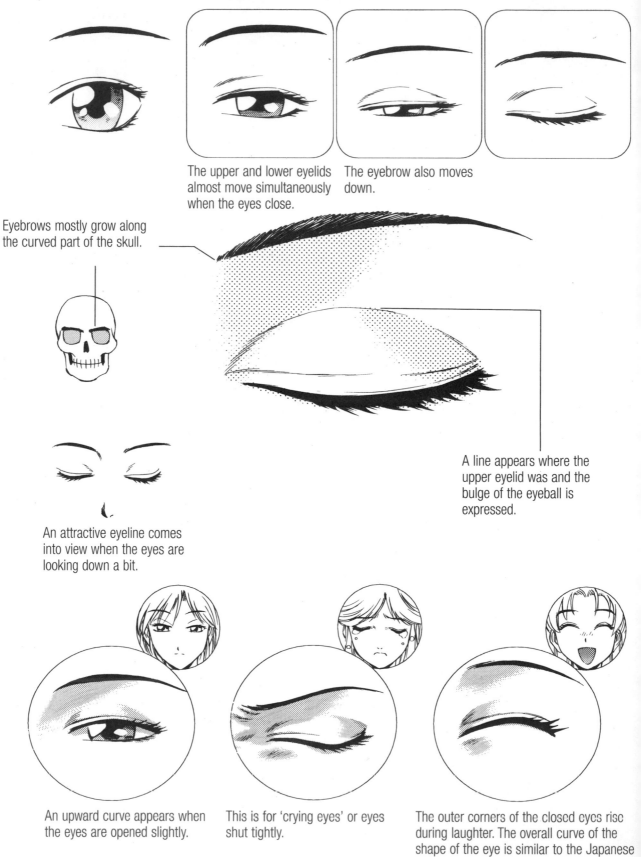

The upper and lower eyelids almost move simultaneously when the eyes close.

The eyebrow also moves down.

Eyebrows mostly grow along the curved part of the skull.

A line appears where the upper eyelid was and the bulge of the eyeball is expressed.

An attractive eyeline comes into view when the eyes are looking down a bit.

An upward curve appears when the eyes are opened slightly.

This is for 'crying eyes' or eyes shut tightly.

The outer corners of the closed eyes rise during laughter. The overall curve of the shape of the eye is similar to the Japanese hiragana character for 'he' —へ.

Handling Shut Eyes

Shut eyes drawn without eyelids

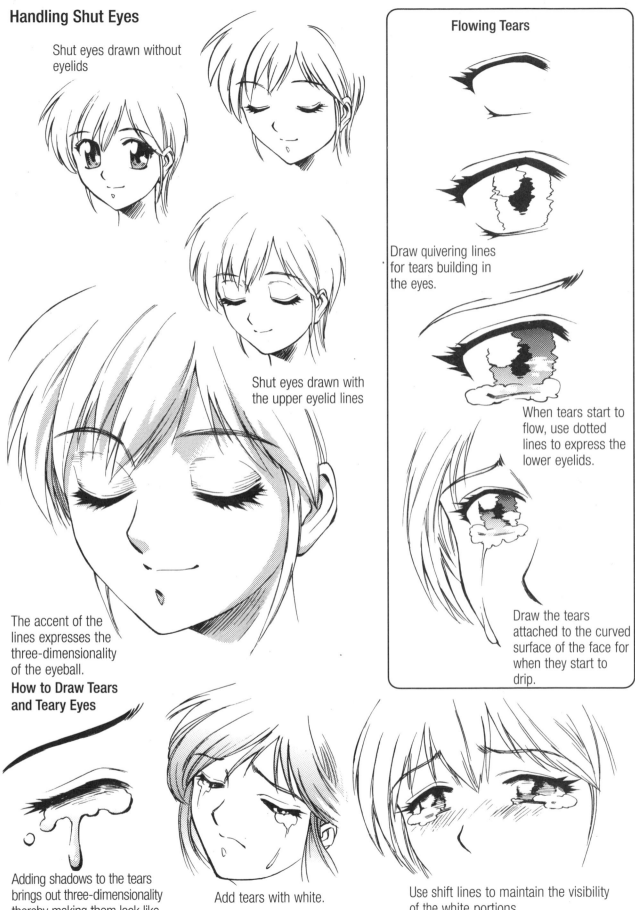

Shut eyes drawn with the upper eyelid lines

The accent of the lines expresses the three-dimensionality of the eyeball.

How to Draw Tears and Teary Eyes

Adding shadows to the tears brings out three-dimensionality thereby making them look like drops of water.

Add tears with white.

Use shift lines to maintain the visibility of the white portions.

Flowing Tears

Draw quivering lines for tears building in the eyes.

When tears start to flow, use dotted lines to express the lower eyelids.

Draw the tears attached to the curved surface of the face for when they start to drip.

Standard Eyed Girls

Standard, real-type eyes are shaped like almonds. These are a basic eye type in manga. Raising the outer corners of the eyes yields up-turned eyes and lowering them yields droopy eyes.

Eyes with a long width (slanted)

Eyes with a long height

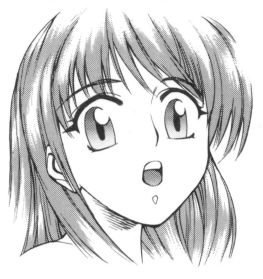

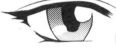

Even normal eyes can appear harsh by 1. Straightening the eyelid or 2. Emphasizing the lower eyelid.

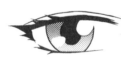

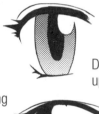

Draw curved lines for both the upper and lower eyelids.

The key to drawing normal eyes is to make the outer corners parallel. Try drawing a guideline for this.

Guideline

Make sure both ends don't go past the guideline.

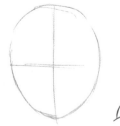

Draw a cross on the forward facing head.

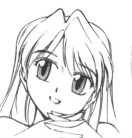

Align the eyes with the guideline and draw curved lines as you please.

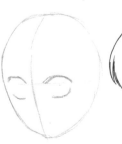

The same procedure can be used for tilted faces.

Droopy Eyed Girls

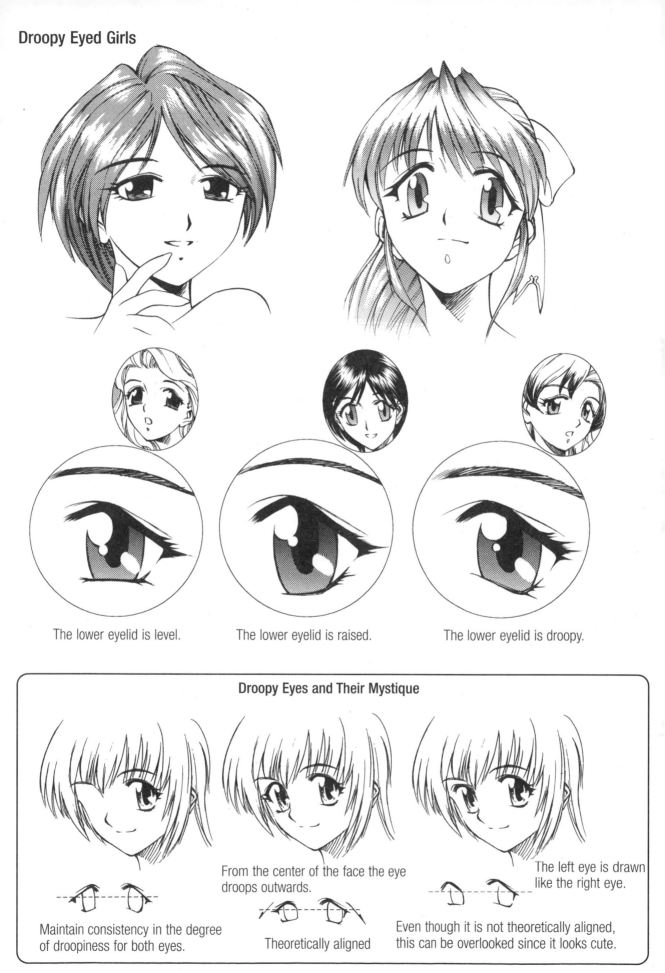

The lower eyelid is level.

The lower eyelid is raised.

The lower eyelid is droopy.

Droopy Eyes and Their Mystique

Maintain consistency in the degree of droopiness for both eyes.

From the center of the face the eye droops outwards.

Theoretically aligned

The left eye is drawn like the right eye.

Even though it is not theoretically aligned, this can be overlooked since it looks cute.

Up-Turned Eyed Girls

With both eyelids raised up

With the upper eyelid raised up

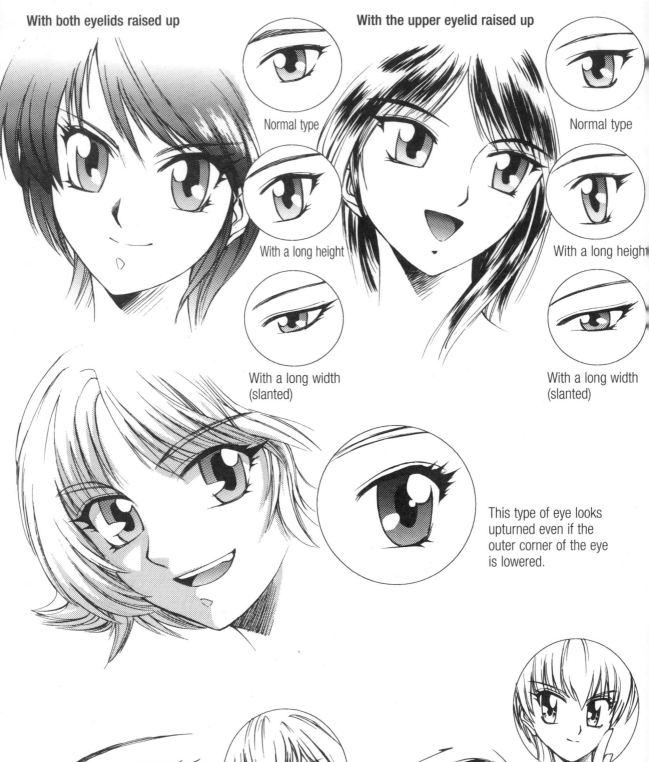

Normal type

Normal type

With a long height

With a long height

With a long width
(slanted)

With a long width
(slanted)

This type of eye looks
upturned even if the
outer corner of the eye
is lowered.

Turn up the eye half way. A
fairly harsh sense is rendered
even if the line after the midway
point is made horizontal.

With a long width (slanted)

The key is to make the
line going up longer than
the one going down.

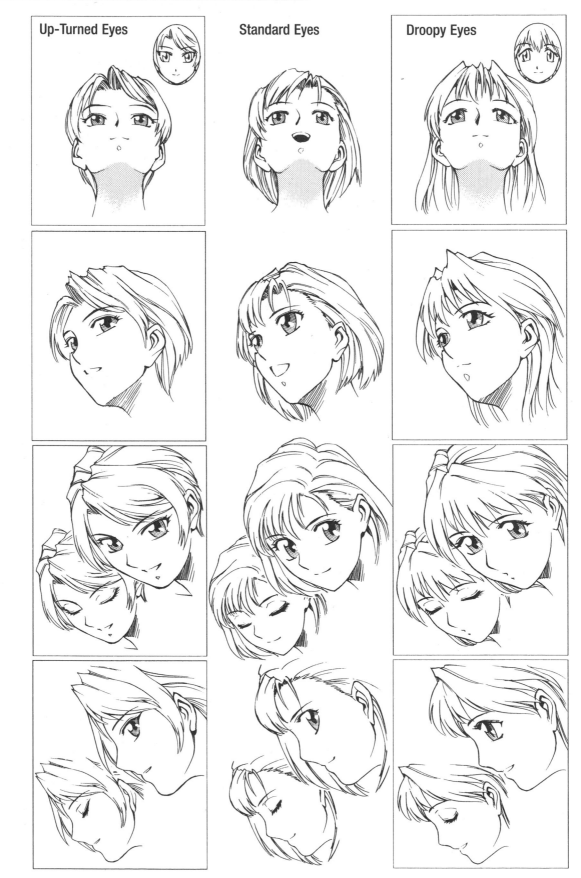

Up-Turned Eyes

Standard Eyes

Droopy Eyes

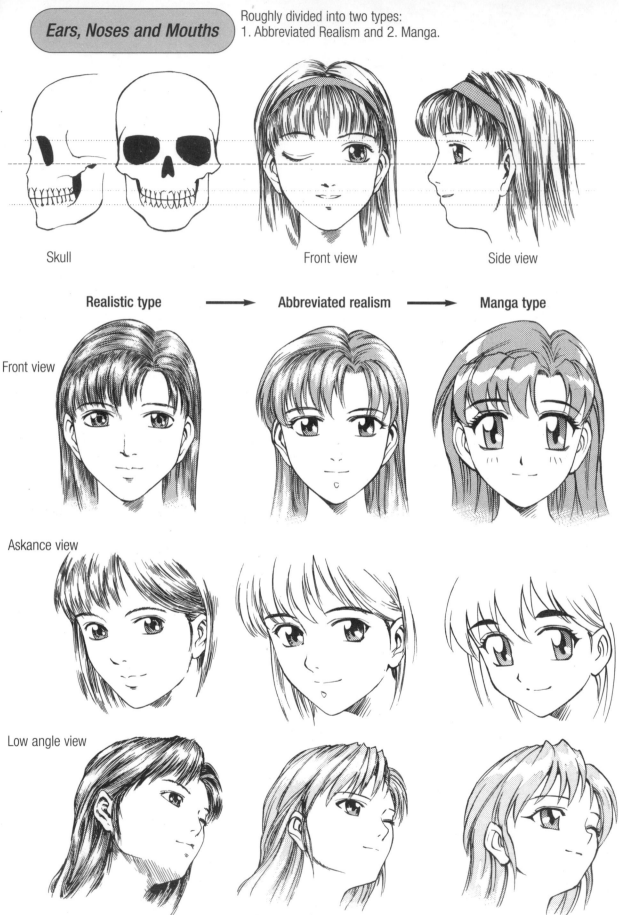

Roughly divided into two types:
1. Abbreviated Realism and 2. Manga.

Skull

Front view

Side view

Realistic type → Abbreviated realism → Manga type

Front view

Askance view

Low angle view

The difference between the two types – realistic and manga – is whether or not the nostrils are drawn.

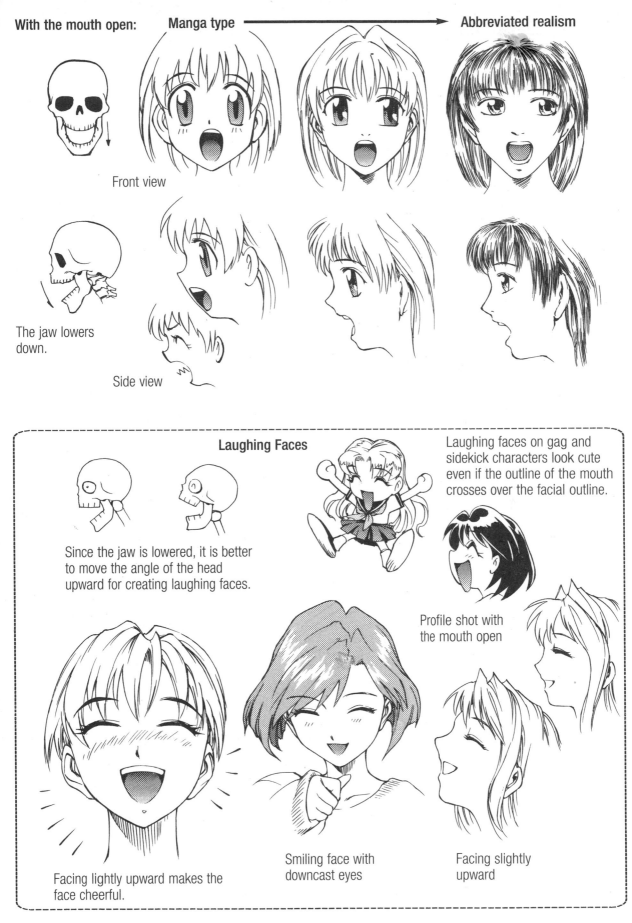

With the mouth open: Manga type ——————→ Abbreviated realism

Front view

The jaw lowers down.

Side view

Laughing Faces

Since the jaw is lowered, it is better to move the angle of the head upward for creating laughing faces.

Laughing faces on gag and sidekick characters look cute even if the outline of the mouth crosses over the facial outline.

Profile shot with the mouth open

Facing lightly upward makes the face cheerful.

Smiling face with downcast eyes

Facing slightly upward

25

The presence of the character and the three-dimensionality of the head are better pronounced when the depth is expressed with the lines of the flowing hair.

Head Depths

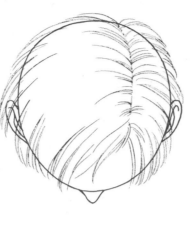

The head is round.

Hair concentrated along a line

Hair concentrated at one point

The two basic types of hair flow are:
1. concentrated along a line or
2. concentrated at one point.

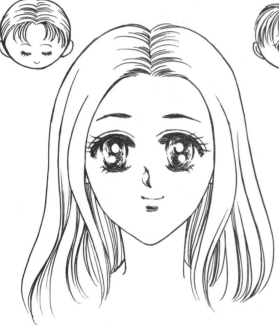

When viewed from the front, the width of the lines in hair gets narrower as you go further back. Use darker, heavier lines along the hairline and parts in the hair.

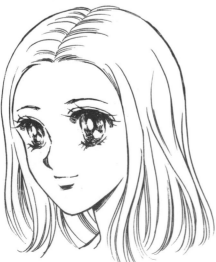

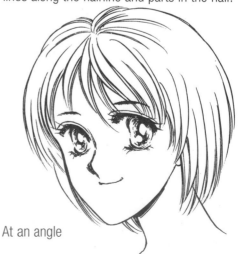

At an angle

The key to the three-dimensionality of the head is the light that hits the hair. The volume of the hair is expressed with the light and shading. Decide which areas to do in black and which areas to keep white.

Draw the head.

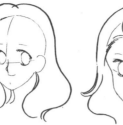

Give shape to the hair as a whole.

Clearly define the parts in the hair, the forehead and the hairline.

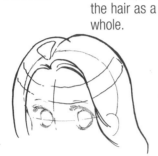

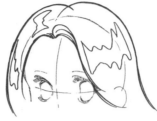

White areas: Decide which areas reflect light. As this is formed by the roundness of the head, use ellipse curves as a guideline.

Divide the hair into blocks.

Areas to be darkened.

The parted area

Hair standing on end

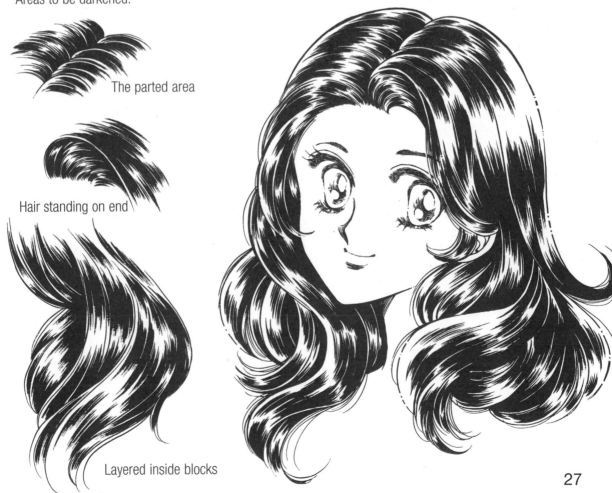

Layered inside blocks

Hairlines and Foreheads

Large/wide forehead

Small/narrow forehead

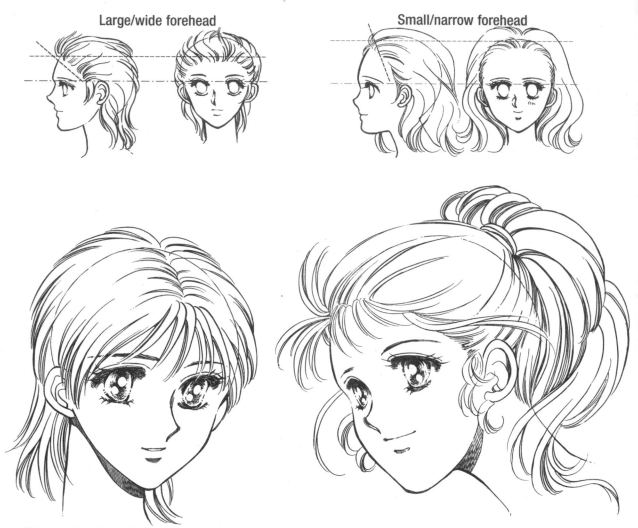

The hair for girls with small foreheads is less voluminous.

Protrusive foreheads for girls allow for elaborate hairdos.

Hairline Management

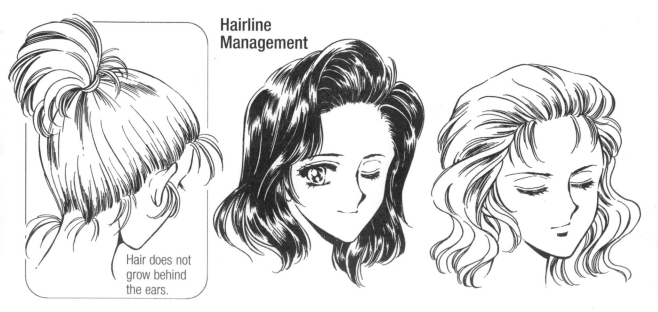

Hair does not grow behind the ears.

Back of the head and ears

28

Tying the Hair Back

Hair gathers in the direction where it is bound. Draw the lines for the hair along the roundness of the skull as if you were drawing a sphere.

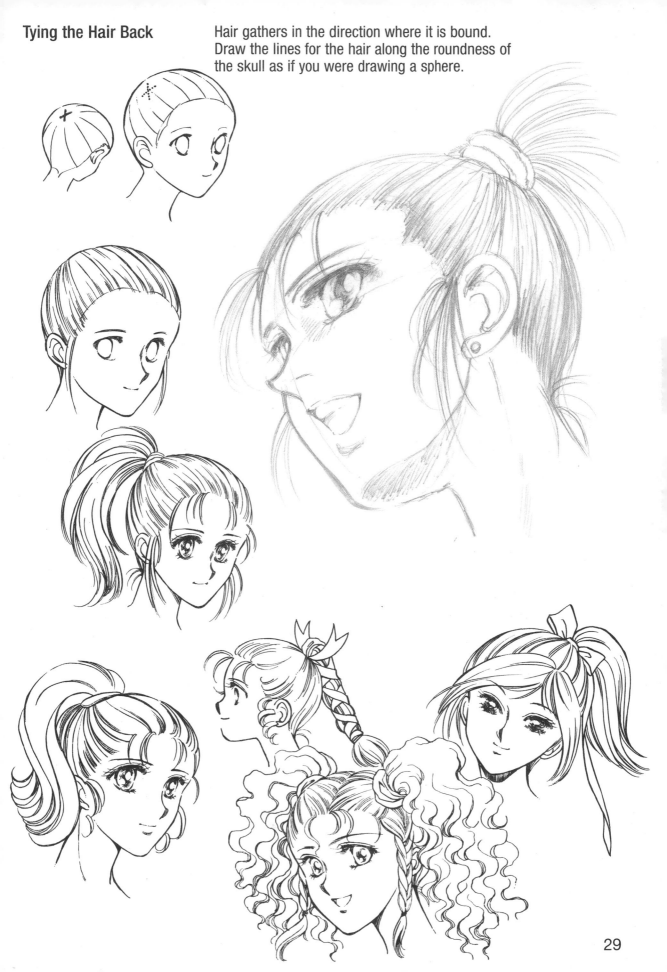

If the act of making faces at someone is drawn too realistically, it looks unexpectedly grotesque; however, arranging the mouth and tongue in a mangaesque manner can be used to visually direct extremely cute characters.

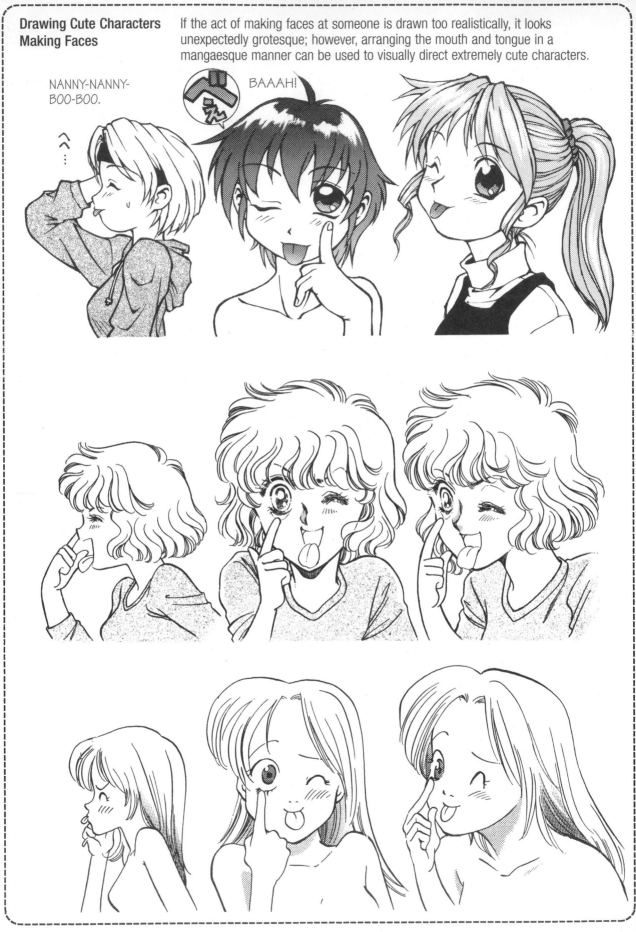

NANNY-NANNY-
BOO-BOO.

BAAAH!

Chapter 2

BISHOUJO Bodies

Balancing Heads and Bodies

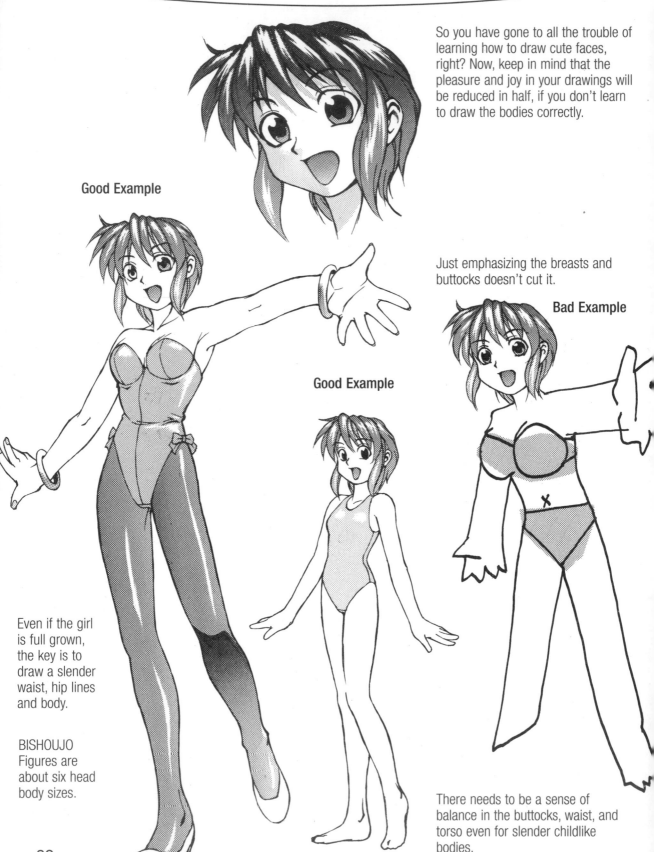

So you have gone to all the trouble of learning how to draw cute faces, right? Now, keep in mind that the pleasure and joy in your drawings will be reduced in half, if you don't learn to draw the bodies correctly.

Good Example

Just emphasizing the breasts and buttocks doesn't cut it.

Bad Example

Good Example

Even if the girl is full grown, the key is to draw a slender waist, hip lines and body.

BISHOUJO Figures are about six head body sizes.

There needs to be a sense of balance in the buttocks, waist, and torso even for slender childlike bodies.

Drawing Waists

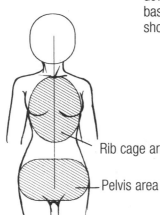

Try drawing an upside down triangle with the base at the breadth of the shoulders.

Rib cage area

Pelvis area

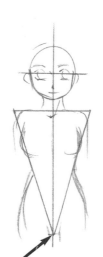

Structurally, the waist is the compressed area between the rib cage area and the pelvis area.

Use the apex of the triangle placed in the area between the legs as a yardstick.

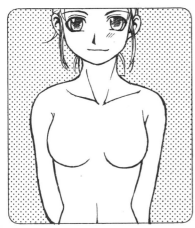

A medium close shot of the bust is good for showing BISHOUJO in a bewitching manner. But the lines approaching the waist are also a good way to appealingly show the bust.

If the waist is not compressed, it simply won't work no matter how big the bust and buttocks are drawn.

By cheating a little and compressing the waist, the girl's style can be made to look appealing.

Even a circle and a triangular ruler can make a girl as long as the waist is drawn compressed.

33

Drawing Slender Bodies

Female figures can be divided into two general groups. The common feature in both of these is the slenderness of the body.

Reducing the Flesh

Trim the flesh from the especially developed areas.

The voluptuous type

The slim type

Increasing the Flesh

Slim

Voluptuous

Adding flesh to the bust and buttocks and leaving the hands, feet and waist untouched can create a voluptuous BISHOUJO.

Shoulder Breadth and Figures

Varying the breadth of the shoulders can increase BISHOUJO varieties.

Narrow Shouldered Girls

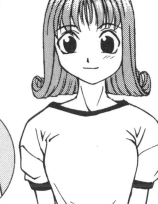

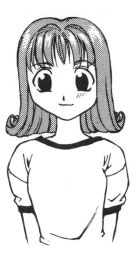

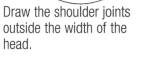

Draw the shoulder joints outside the width of the head.

The adult nature abounds in this cool little lady.

Draw the shoulder joints inside the width of the head.

The childish nature abounds in this petite cutie.

It is easier to draw long torsos and express adult figures with girls with wide shoulders.

The neck needs to be drawn a bit on the long side for girls with narrow shoulders. Otherwise, the girl will look like she is shrugging her shoulders.

Flowing Bodylines

Bodyline – Front View The silhouette of the bodyline differs whether the subject is wearing a bra or not.

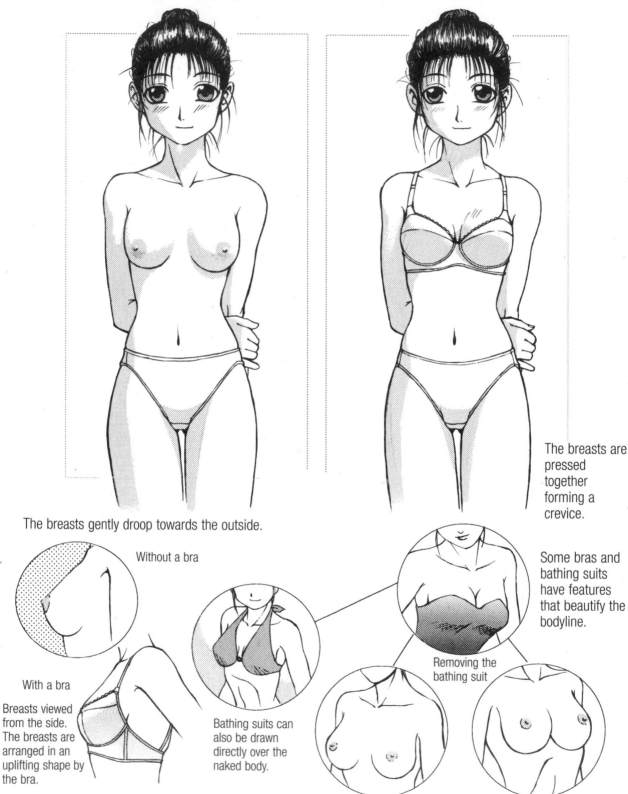

The breasts are pressed together forming a crevice.

The breasts gently droop towards the outside.

Without a bra

Some bras and bathing suits have features that beautify the bodyline.

Removing the bathing suit

With a bra

Breasts viewed from the side. The breasts are arranged in an uplifting shape by the bra.

Bathing suits can also be drawn directly over the naked body.

The chest to the lower abdomen area is comprised of complex curves.
The three-dimensional expression varies depending on the areas to be emphasized.

Draw hip lines and other lines that reach from the lower abdomen to the area between the legs. The lines reaching between the legs emphasize the three-dimensionality and the roundness of the lower abdomen.

Draw the lines of the ribs. This helps to heighten the slenderness of the area below the chest.

Simple body curves with the naval placed in the gently rising area of the lower abdomen.

The line in the center of the abdomen highlights the slenderness. This is often used to express adult women who are a bit on the muscular side.

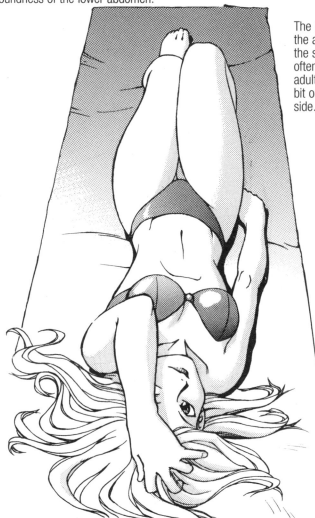

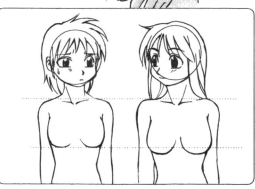

The distance from the shoulder to the beginning of the bulging is a bit on the short side for girls with small breasts.

Back Lines
Expressing Shoulder Blades

Solid lines

Oblique lines

The lines of the back are emphasized when both arms are raised in the air and tension enters the muscles causing the shoulder blades to protrude.

The shoulder blades do not protrude when the arms are at the side; thus, the lack of tension in muscles results in a simple back line.

For shots where a part of the breasts can be seen from the side and from behind, the body looks thicker since the parts viewed from the side come clearly into view.

Side Lines – From the Armpits to the Side

The body looks thicker for shots where the side of the body can be seen; however, once the lines are draw on the side, they won't bother you that much.

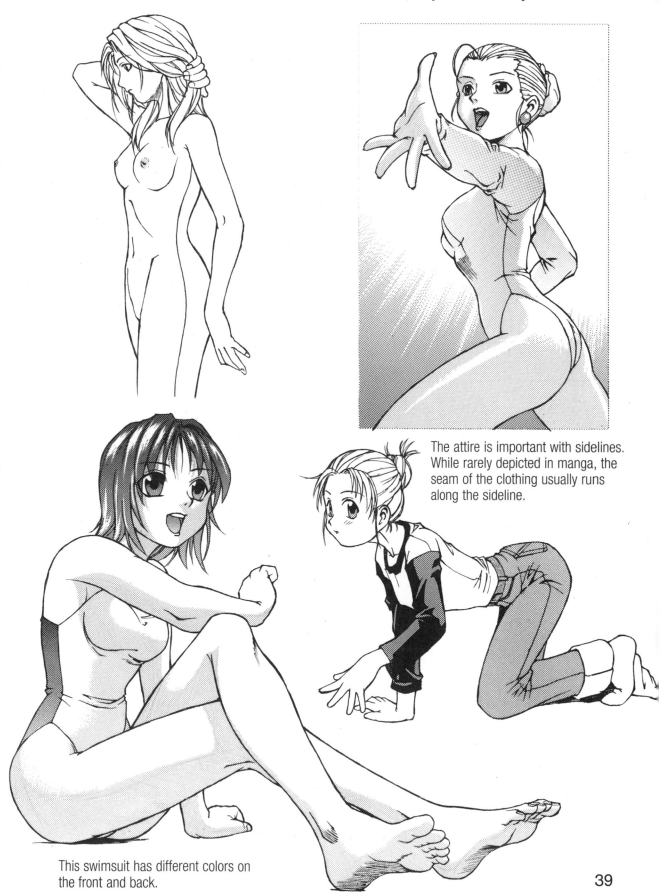

The attire is important with sidelines. While rarely depicted in manga, the seam of the clothing usually runs along the sideline.

This swimsuit has different colors on the front and back.

Bending Bodies
Visually Directing Cuteness

By devising the connections between the neck, shoulder and waist, the cuteness of the character, as well as, the inner feelings and personality contained in unintentional gestures and actions can be visually directed.

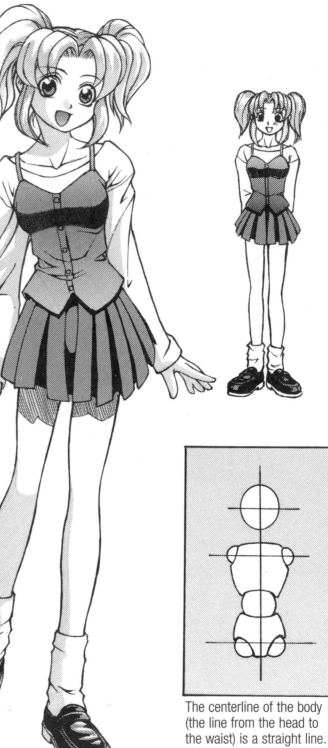

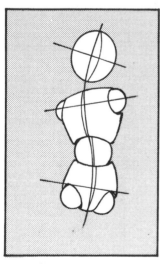

This is a bending pose created by drawing the centerline of the body like the letter S.

The centerline of the body (the line from the head to the waist) is a straight line. The horizontal lines of the shoulders and waist are parallel in this standing upright pose.

The key here is to raise the shoulder of the side of the tilting neck while raising the hip on the opposite side. The bending in the body comes to life by making the neck, shoulders and hips alternatively go up and down. Physically, this also includes the twisting of the body.

The shoulder and hip correspondingly move together.

A slight tilt of the head will not cause a movement in the shoulder nor the hip.

Be careful not to loose the cuteness of the character by destroying the balance by too much titling.

CAUTION: Don't Overtilt

Correct Divergences in the Balance with Feet Position

Divergences in the balance translate into divergences in the center of gravity. This, however, can be corrected depending on how the legs are positioned.

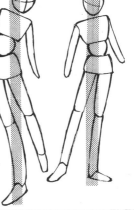

Drawing Breasts

The key to expressing an appealing bust is to make it a part of the entire figure. Decide the position and size of the bust while keeping the entire body in mind.

① Draw a rough outline giving shape to the body.

② Roughly decide the position of the breasts drawing them in.

③ Complete the drawing. (Choose the size according to your taste and needs.)

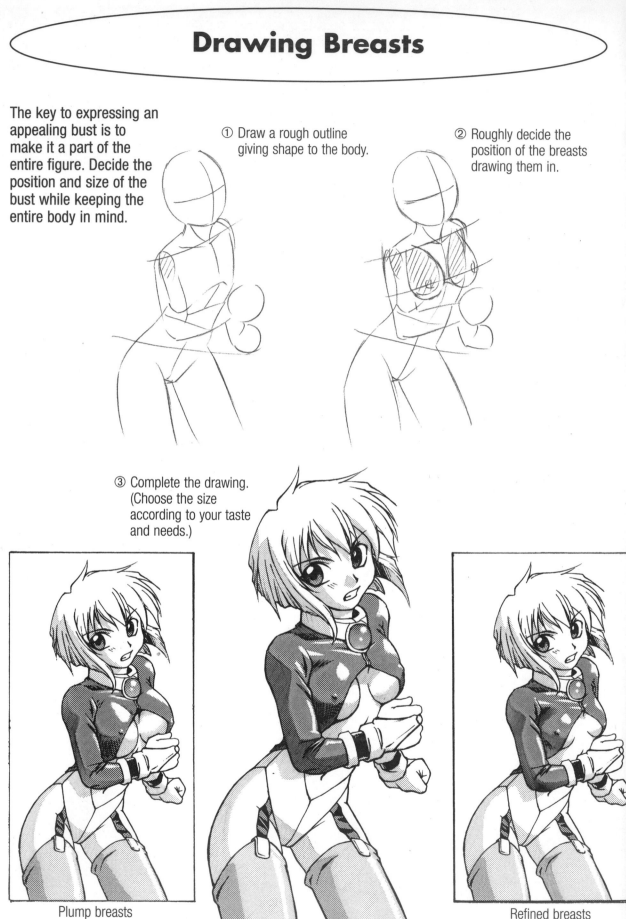

Plump breasts

Refined breasts

There are a variety of sizes and shapes for breasts depending on individual preferences, but the positioning is about the same. However, large breasts tend to droop a bit due to their weight.

When objects come into contact with the breasts, they gently sink in. Handle situations like this by moving the breasts to the left and right, up and down. The key is to avoid making them too angular.

The base is the same.

When being held up with the arms

Reference Work: disregards gravity completely

When resting on the edge of a desk

Breasts that are large and do not droop are particularly expressed in manga.

Be Careful with Pen Touches

Accent the soft, plump roundness of the breasts. By paying attention to the curved lines, even smaller breasts can be made to look soft and beautiful.

Continuous Movement and Girls

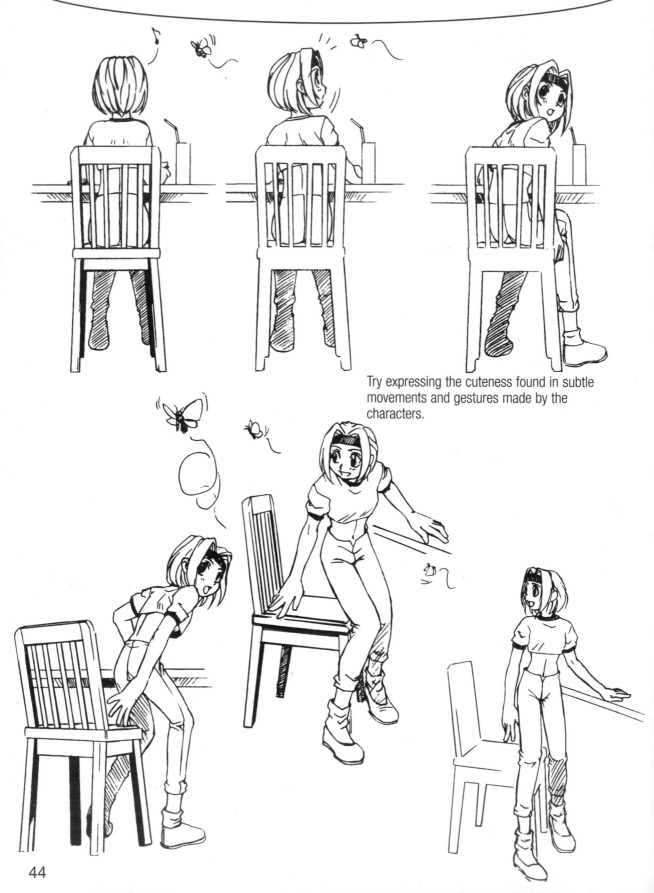

Try expressing the cuteness found in subtle movements and gestures made by the characters.

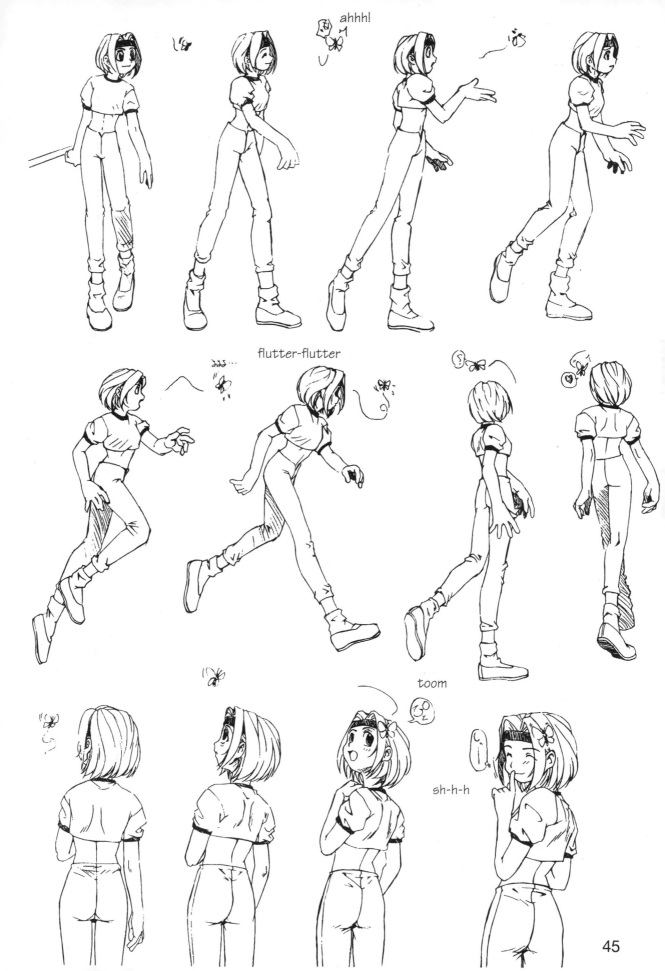

ahhh!

flutter-flutter

toom

sh-h-h

45

High and Low Angles

High angles shots are often used when you want to show an appealing chest.

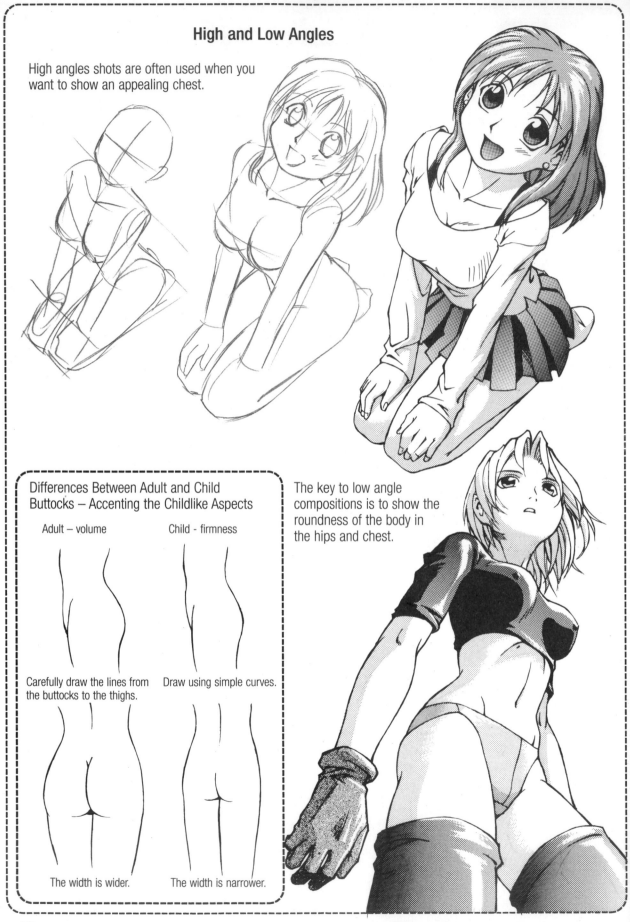

Differences Between Adult and Child Buttocks – Accenting the Childlike Aspects

Adult – volume

Child - firmness

Carefully draw the lines from the buttocks to the thighs.

Draw using simple curves.

The width is wider.

The width is narrower.

The key to low angle compositions is to show the roundness of the body in the hips and chest.

Chapter 3

Situations and Techniques of Expression

Changing Clothes

Taking Off Jackets

The character bends forward a bit when removing the jacket around the arms.

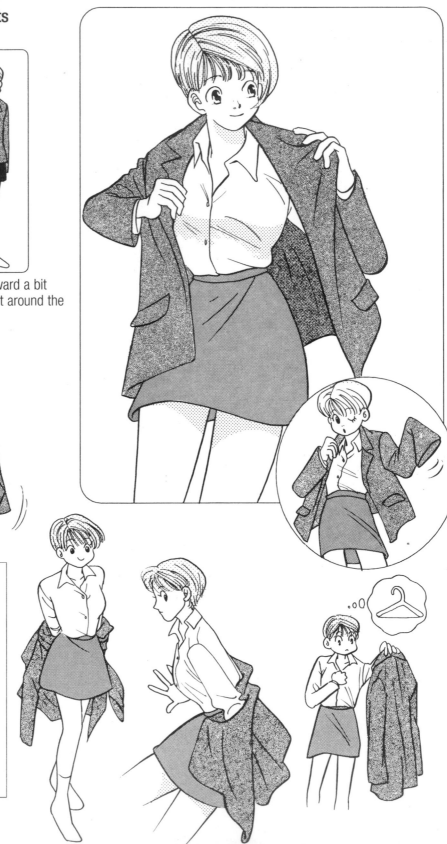

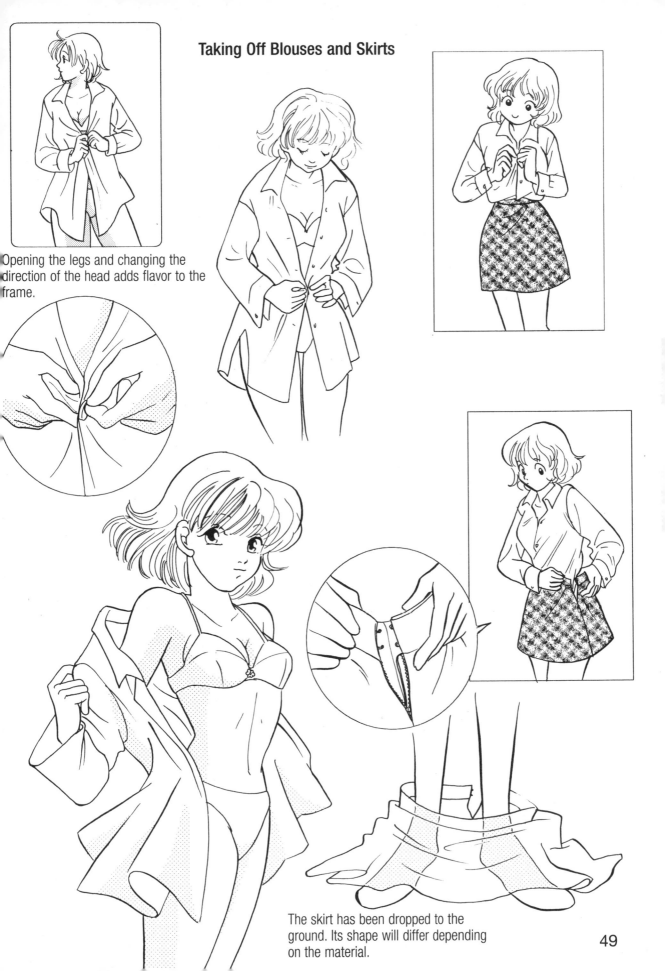

Taking Off Blouses and Skirts

Opening the legs and changing the direction of the head adds flavor to the frame.

The skirt has been dropped to the ground. Its shape will differ depending on the material.

Putting On T-Shirts

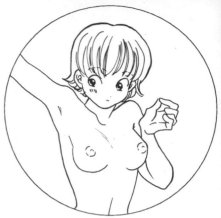

Draw a see-through composition to use as a reference when you are not sure.

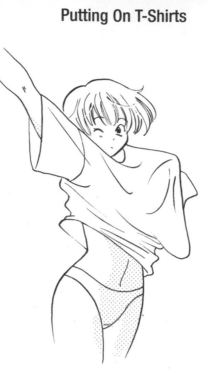

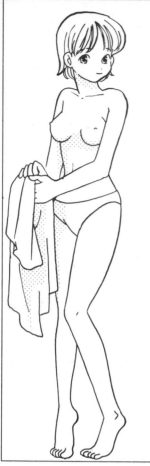

Undressing

When putting on clothes, girls usually start from the top and work their way down.

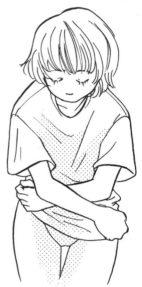

Round necked clothing or turtlenecks cannot be removed without removing the arm sections first. Use wrinkles in the clothing to express the arm inside the clothing.

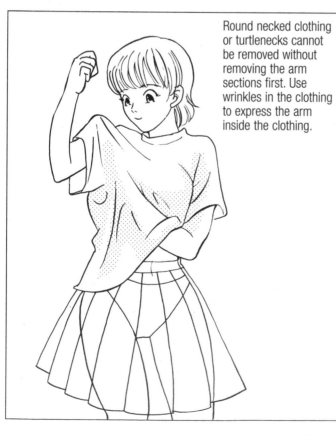

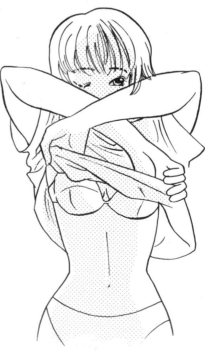

Putting On Jeans

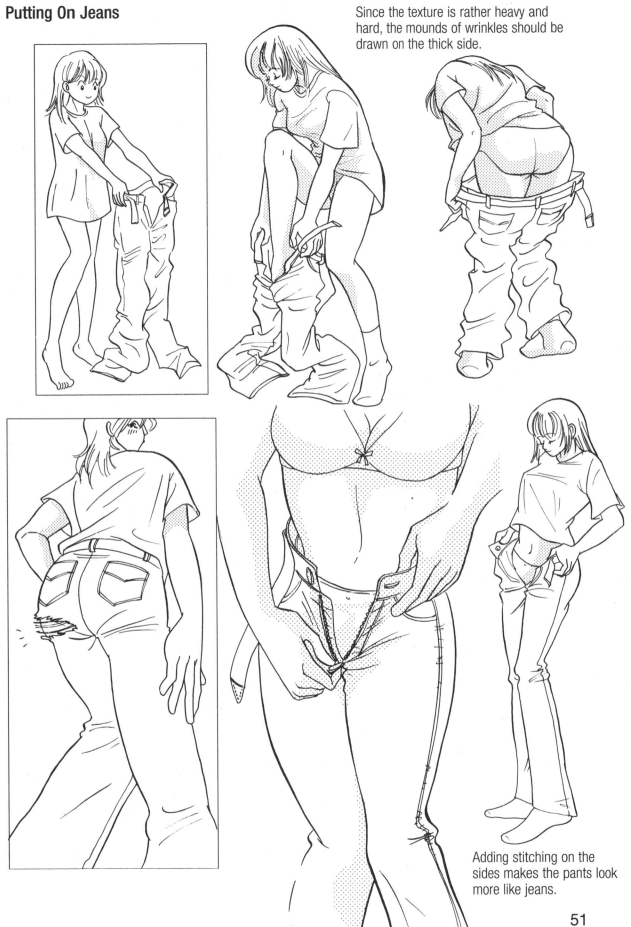

Since the texture is rather heavy and hard, the mounds of wrinkles should be drawn on the thick side.

Adding stitching on the sides makes the pants look more like jeans.

Yukata: Japanese Dressing Gowns

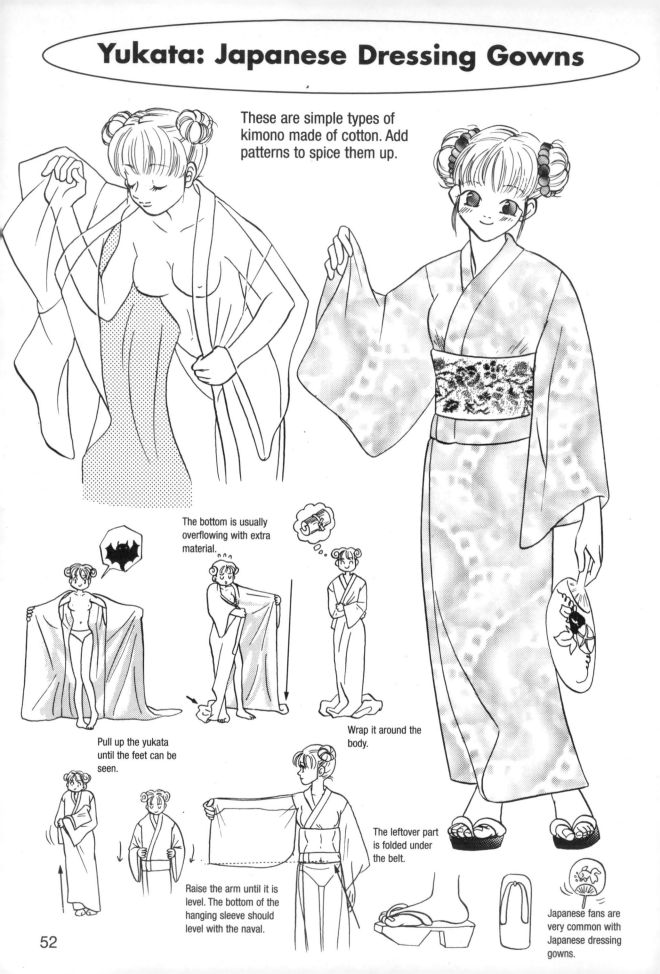

These are simple types of kimono made of cotton. Add patterns to spice them up.

The bottom is usually overflowing with extra material.

Pull up the yukata until the feet can be seen.

Wrap it around the body.

Raise the arm until it is level. The bottom of the hanging sleeve should level with the naval.

The leftover part is folded under the belt.

Japanese fans are very common with Japanese dressing gowns.

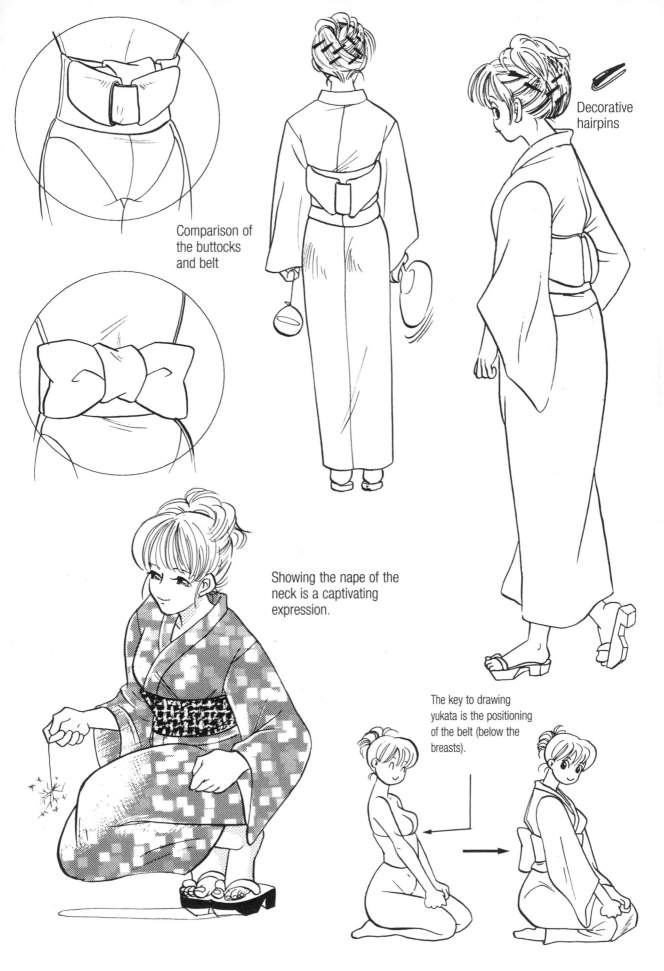

Comparison of
the buttocks
and belt

Decorative
hairpins

Showing the nape of the
neck is a captivating
expression.

The key to drawing
yukata is the positioning
of the belt (below the
breasts).

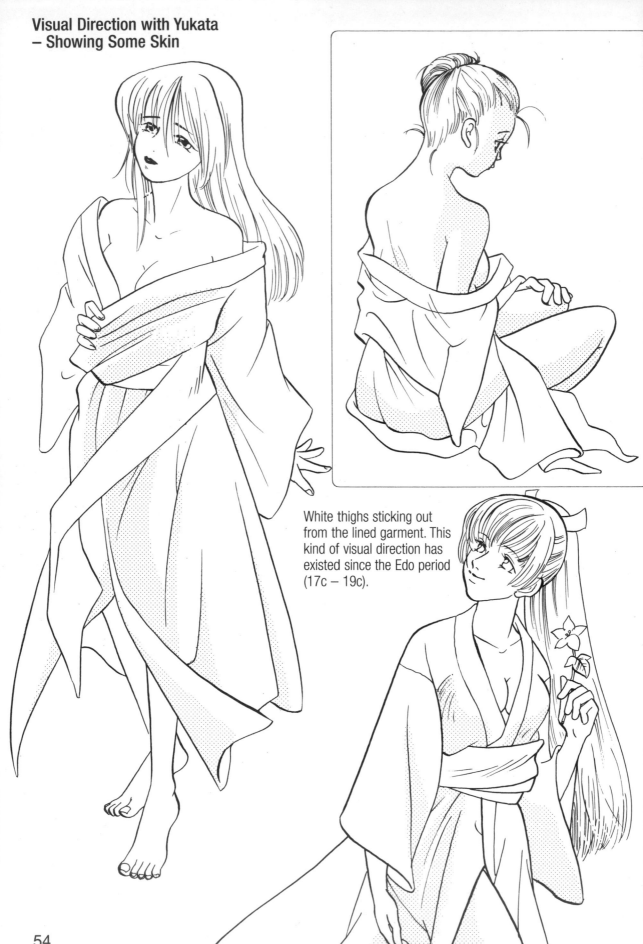

White thighs sticking out from the lined garment. This kind of visual direction has existed since the Edo period (17c – 19c).

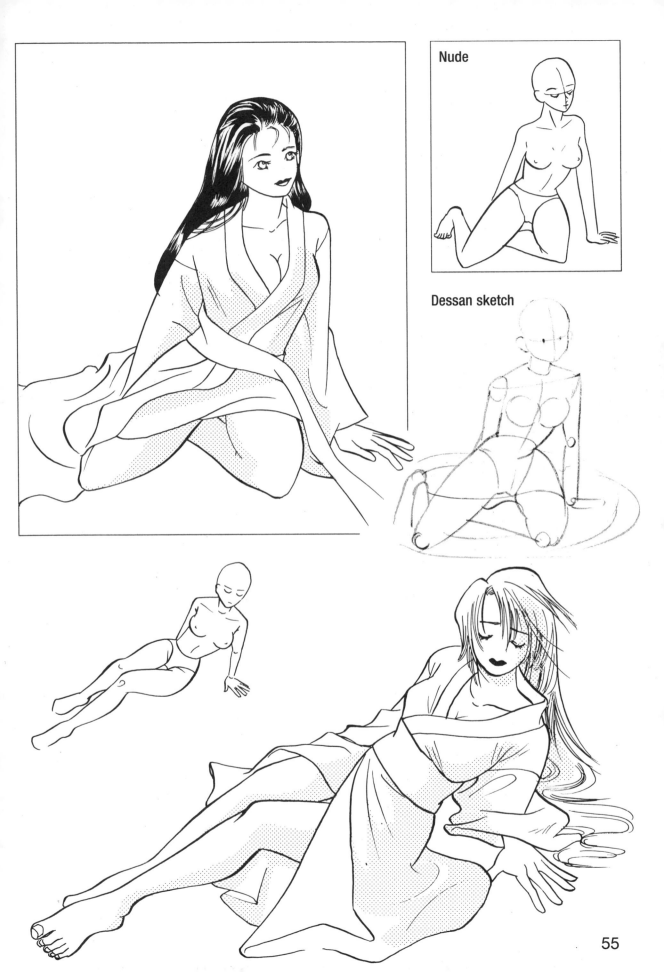

Nude

Dessan sketch

Taking Off Clothing Before a Bath

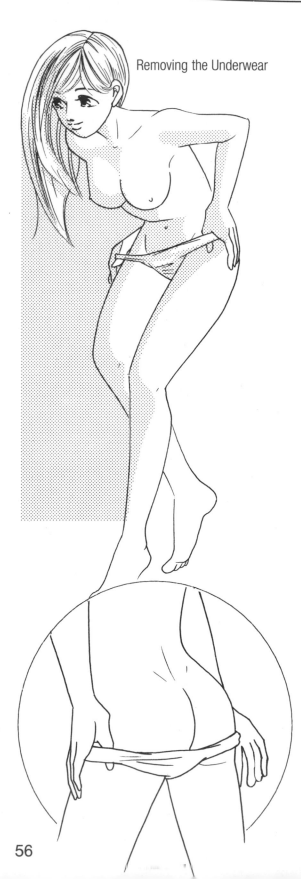

Removing the Underwear

Pulling the leg out

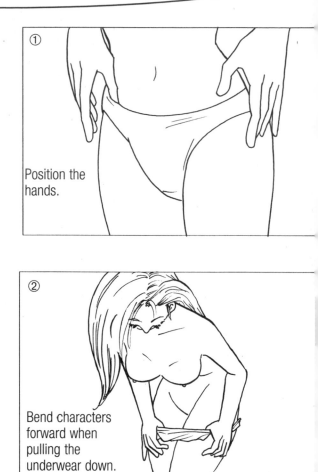

① Position the hands.

② Bend characters forward when pulling the underwear down.

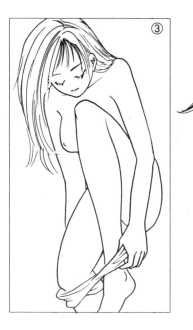

③

④

Taking Off Bras

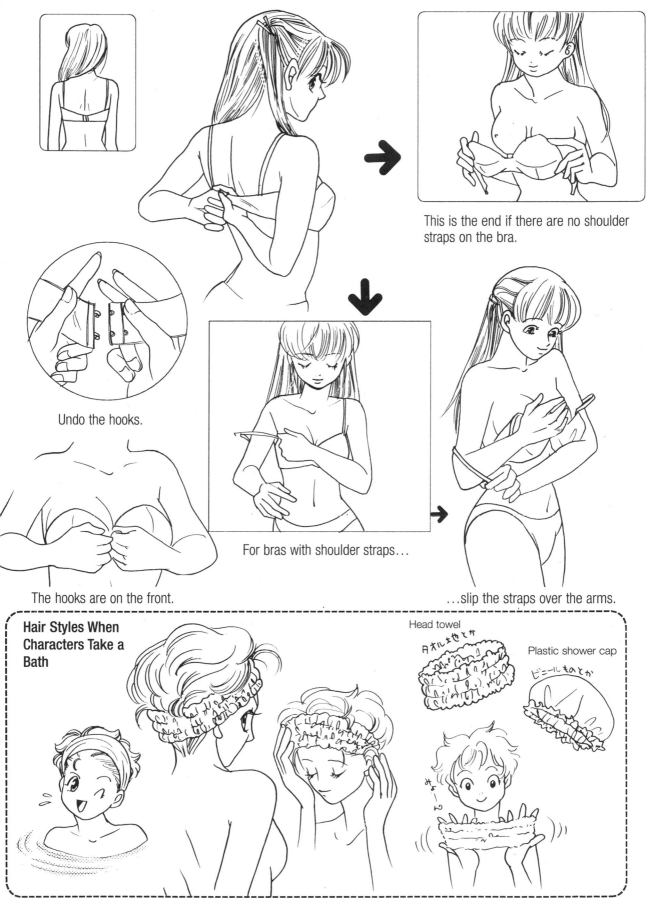

This is the end if there are no shoulder straps on the bra.

Undo the hooks.

The hooks are on the front.

For bras with shoulder straps…

…slip the straps over the arms.

Hair Styles When Characters Take a Bath

Head towel

タオル土やとか

Plastic shower cap

ビニールものとか

みゃーな

57

Bathtub and Shower Scenes

Soaking in Bathtubs

Bath scenes make use of various techniques for expressing sweat and steam as well as characters inside and outside of the water.

Carefully draw the sweat as well as the contours of the water along the bust area.

Draw the parts above the surface of the water as you normally would. Draw the parts submerged in the water a bit on the thin side expressing the trembling.

Express the surface of the water using curved lines.

Using white is convenient.

For those areas of the body which can be seen through the steam, shade them by using either dotted or thin lines.

Visually Directing Foam and Steam

Foam is a handy visual direction item for hiding certain areas.

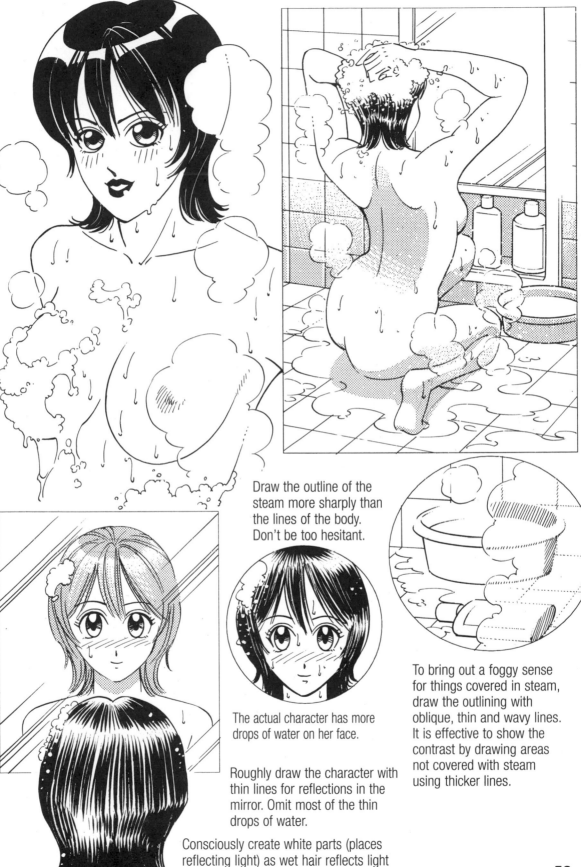

Draw the outline of the steam more sharply than the lines of the body. Don't be too hesitant.

The actual character has more drops of water on her face.

Roughly draw the character with thin lines for reflections in the mirror. Omit most of the thin drops of water.

Consciously create white parts (places reflecting light) as wet hair reflects light easily.

To bring out a foggy sense for things covered in steam, draw the outlining with oblique, thin and wavy lines. It is effective to show the contrast by drawing areas not covered with steam using thicker lines.

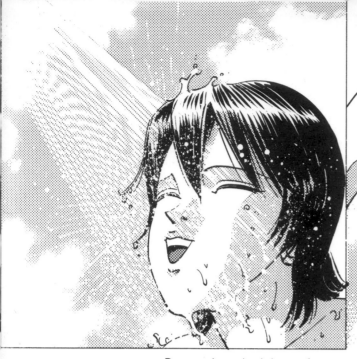

Draw various sized drops of water.

Mixing in gently curved lines with the straight lines of the water creates a soft look.

The force of the water and the heat of the steam can both be visually directed by erasing the facial outline here and there.

Use emphasis lines for the flowing water. Fix the vanishing point far from the nozzle of the shower.

Water Flowing Down Along the Body

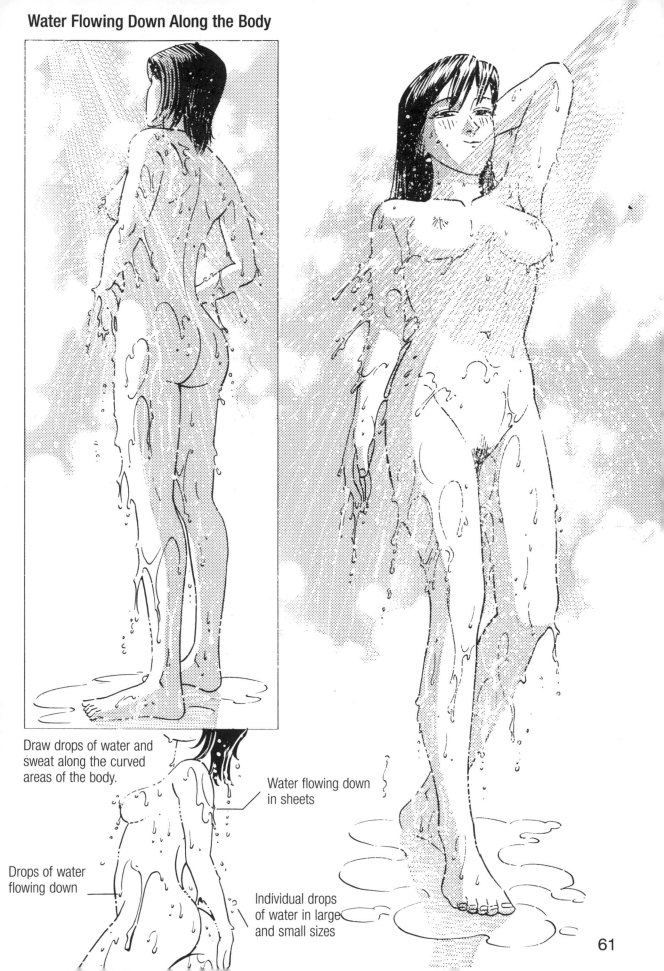

Draw drops of water and sweat along the curved areas of the body.

Water flowing down in sheets

Drops of water flowing down

Individual drops of water in large and small sizes

Wrapping Towels

Around the Head

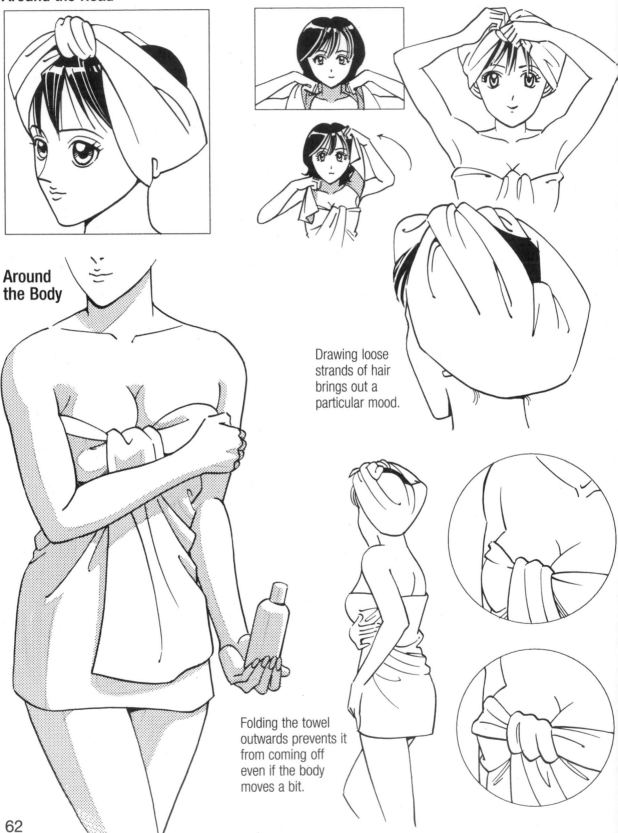

Drawing loose strands of hair brings out a particular mood.

Around the Body

Folding the towel outwards prevents it from coming off even if the body moves a bit.

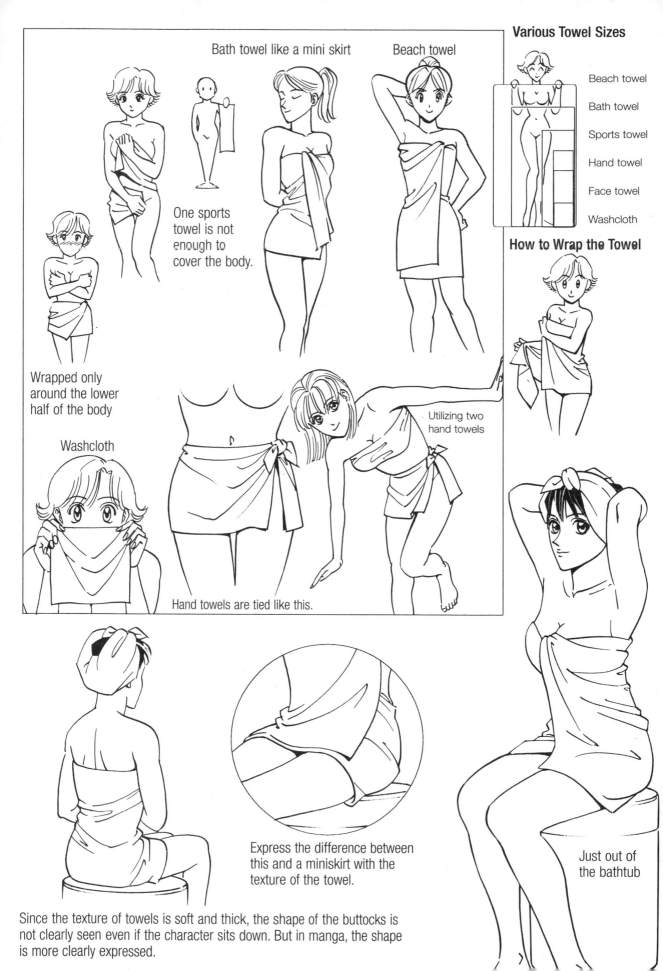

Bath towel like a mini skirt

Beach towel

Various Towel Sizes

Beach towel
Bath towel
Sports towel
Hand towel
Face towel
Washcloth

One sports towel is not enough to cover the body.

How to Wrap the Towel

Wrapped only around the lower half of the body

Washcloth

Utilizing two hand towels

Hand towels are tied like this.

Express the difference between this and a miniskirt with the texture of the towel.

Just out of the bathtub

Since the texture of towels is soft and thick, the shape of the buttocks is not clearly seen even if the character sits down. But in manga, the shape is more clearly expressed.

Working with Lingerie

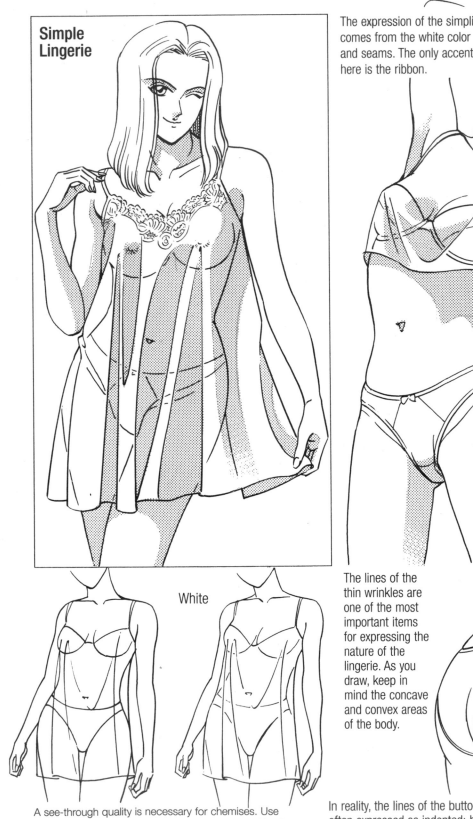

Simple Lingerie

White

A see-through quality is necessary for chemises. Use white to erase parts of the body that are covered by the wrinkle lines.

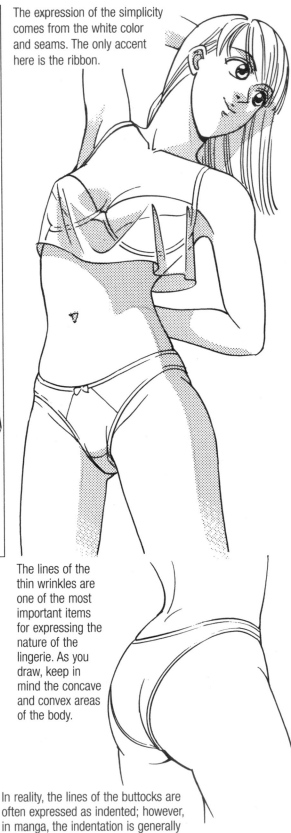

The expression of the simplicity comes from the white color and seams. The only accent here is the ribbon.

The lines of the thin wrinkles are one of the most important items for expressing the nature of the lingerie. As you draw, keep in mind the concave and convex areas of the body.

In reality, the lines of the buttocks are often expressed as indented; however, in manga, the indentation is generally drawn with a line.

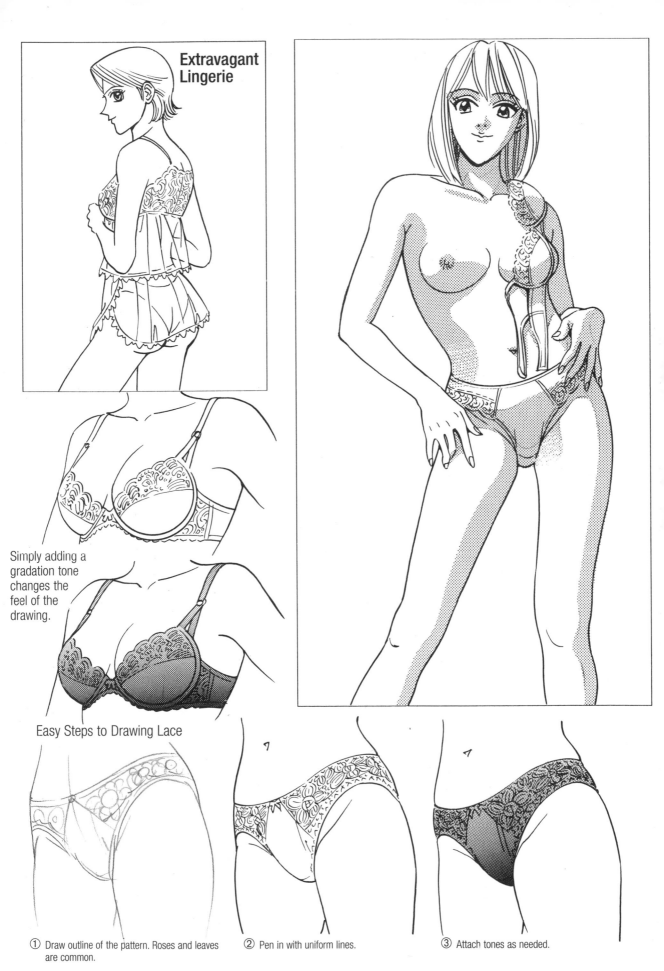

Extravagant Lingerie

Simply adding a gradation tone changes the feel of the drawing.

Easy Steps to Drawing Lace

① Draw outline of the pattern. Roses and leaves are common.

② Pen in with uniform lines.

③ Attach tones as needed.

Dressing for Bed

Pajamas and Negligee

Draw with the intention of expressing a relaxed feeling of leisure and comfort.

Pajamas are somewhat loose fitting.

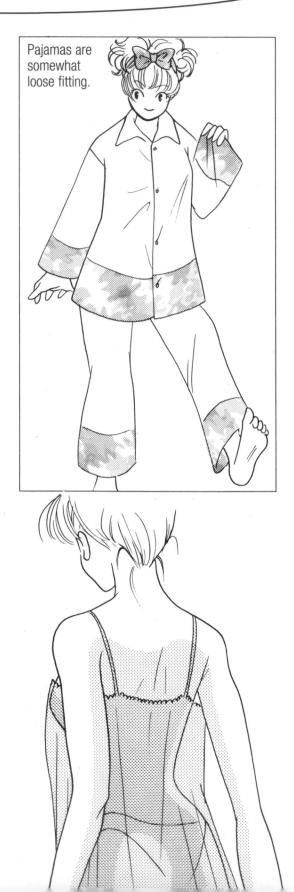

Drawing negligee is about the same as drawing nightgowns and slips.

T-Shirts

Fundamentally the T-shirt drops straight down over the waist, but sometimes as a visual directional choice, the waist and the manner in which the clothing is worn can be emphasized.

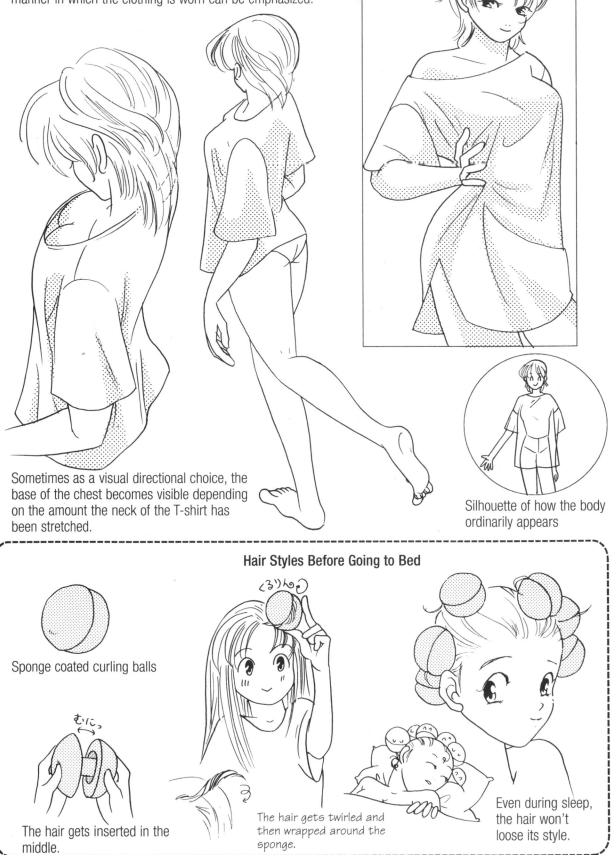

Sometimes as a visual directional choice, the base of the chest becomes visible depending on the amount the neck of the T-shirt has been stretched.

Silhouette of how the body ordinarily appears

Hair Styles Before Going to Bed

Sponge coated curling balls

The hair gets inserted in the middle.

The hair gets twirled and then wrapped around the sponge.

Even during sleep, the hair won't loose its style.

Visual Direction Effects Using Sheets

Wrapping Characters in Sheets Depict the scene with sturdy lines. The key is to avoid drawing too many wrinkles.

Once the body is wrapped in the sheets, draw the remaining areas a bit on the showy side. A rough estimate with your eyes is fine as long as it looks cool.

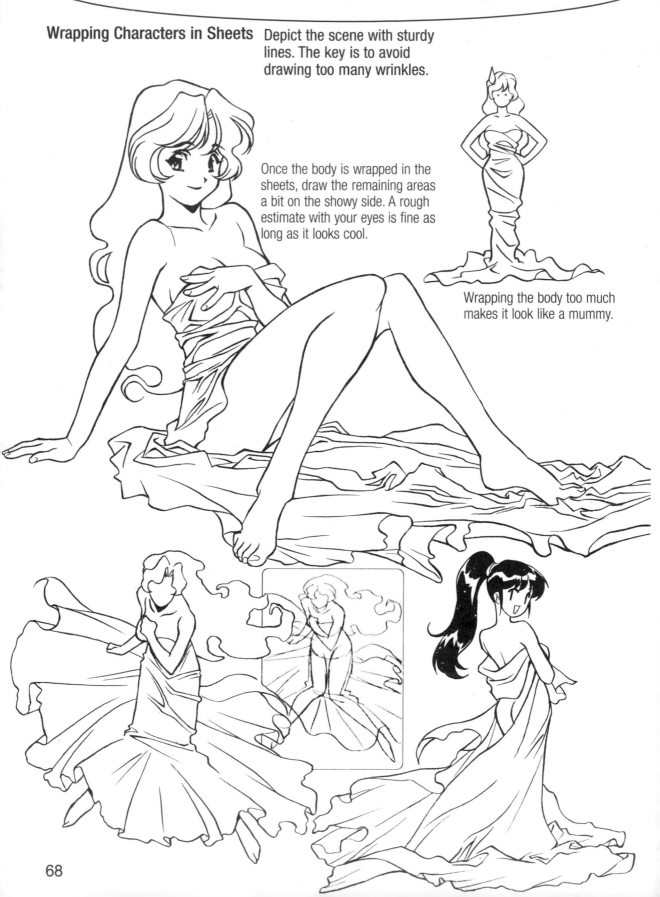

Wrapping the body too much makes it look like a mummy.

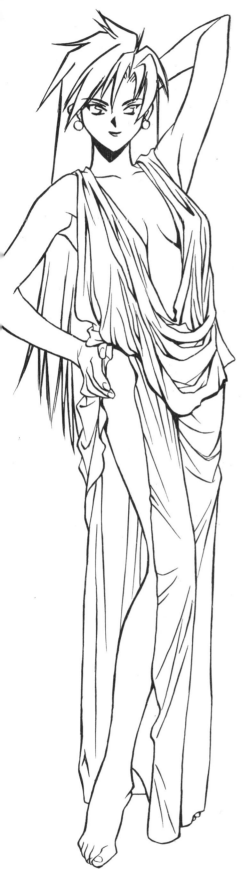

How about a long skirt for setting the mood? Adding some shadows brings out composure in the scene.

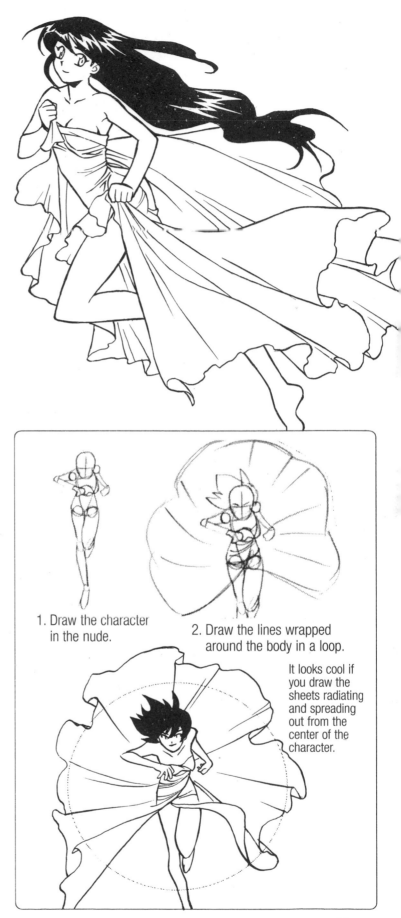

1. Draw the character in the nude.

2. Draw the lines wrapped around the body in a loop.

It looks cool if you draw the sheets radiating and spreading out from the center of the character.

Sheets and Sleeping Poses

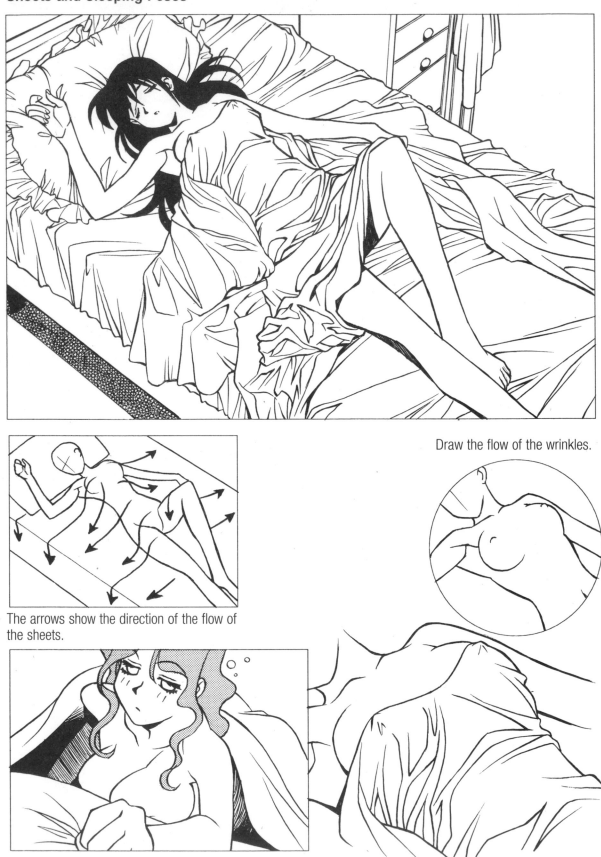

The arrows show the direction of the flow of the sheets.

Doing the shadows in pen or with shift lines brings out the depth and enhances the 'life' in the scene.

Draw the flow of the wrinkles.

Make the lines of the wrinkles sharp.

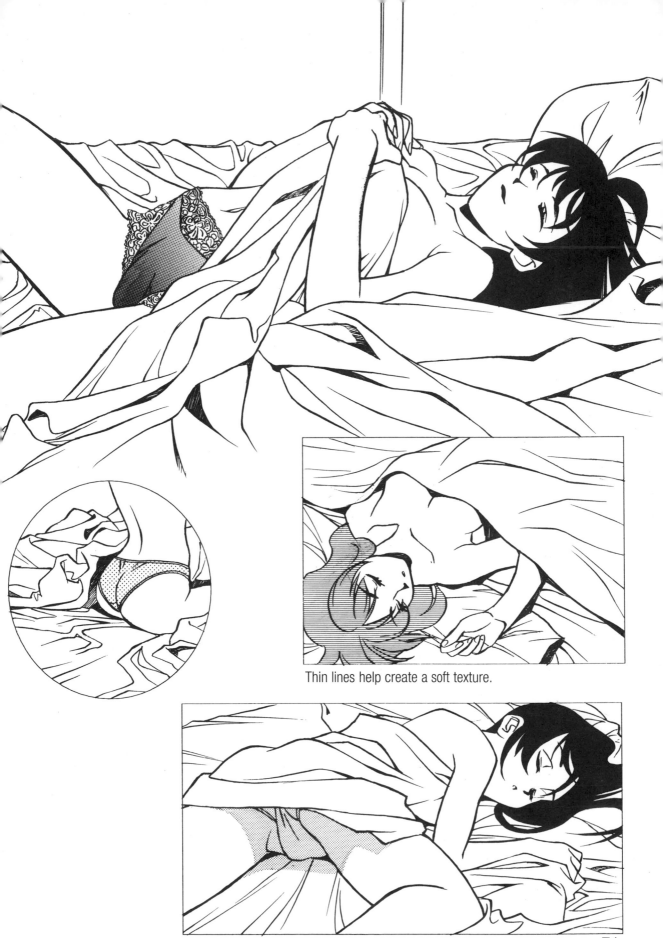

Thin lines help create a soft texture.

Thick lines make the sheets look thick and hard.

Use Tones to Express Suntans

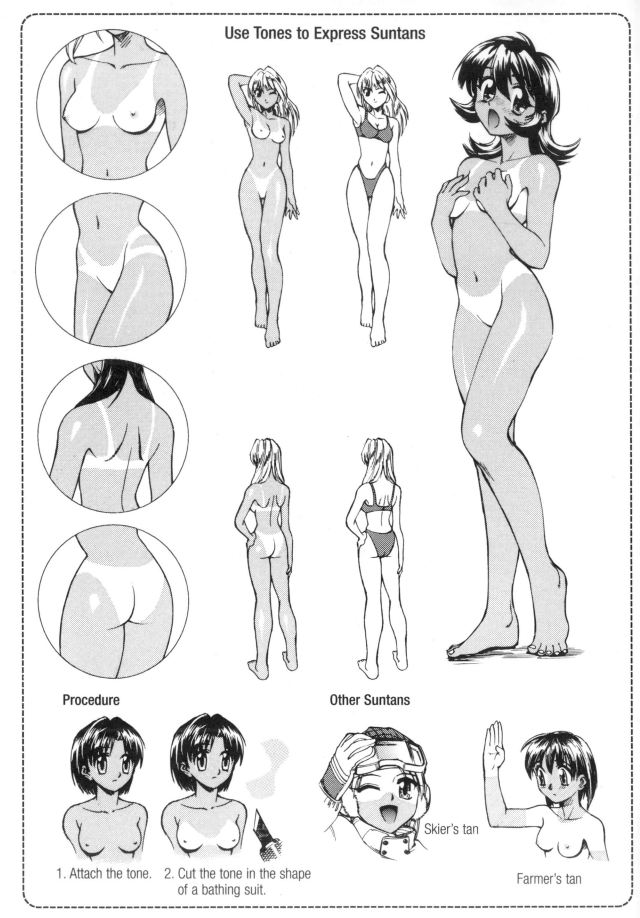

Procedure

1. Attach the tone.
2. Cut the tone in the shape of a bathing suit.

Other Suntans

Skier's tan

Farmer's tan

Chapter 4

Every Day Life BISHOUJO

Girls with Glasses

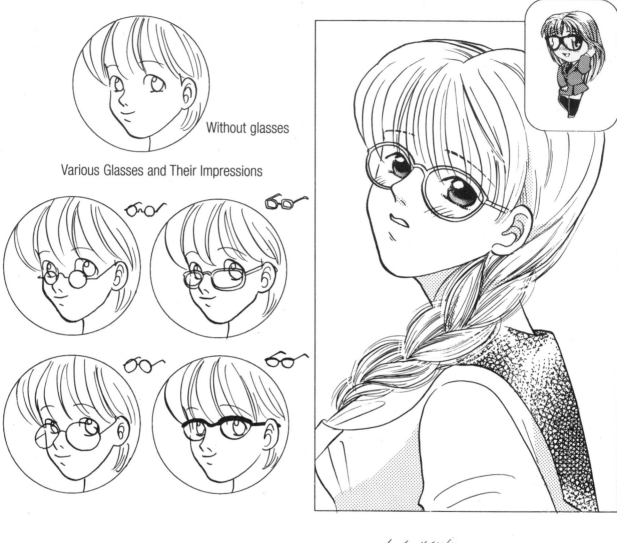

Without glasses

Various Glasses and Their Impressions

Simple Drawing Method 1

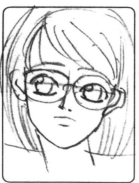

1. First, draw the face as you desire and then add glasses.

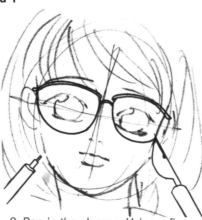

2. Pen in the glasses. Using a fine-point pen and an oval shaped ruler or ribbed ruler helps make the lines sharp. Drawing the edges freehand also works well.

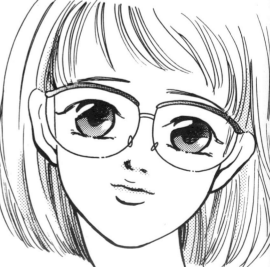

3. After drawing the glasses, complete the drawing by darkening the outlines of the eyes and eyebrows.

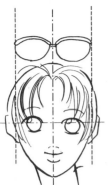

Glasses are usually smaller than the width of the head; however, there are exceptions to this rule based on the design of the glasses.

The frame is widened and then put on.

The frames of the glasses hide the eyebrows.

This mangaesque representation of glasses when used in scenes with reality is good for a laugh.

Wraparound glasses hide the eyes from the side.

Viewed from the side, the glass looks like a plate.

Simple Drawing Method 2 Once you get used to drawing glasses, it is faster to draw them first and then focus on drawing the face.

Expressing Lenses

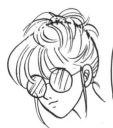

The eyes are not drawn at all under full reflection.

The outlines behind the glasses are drawn with fine lines with portions erased with white.

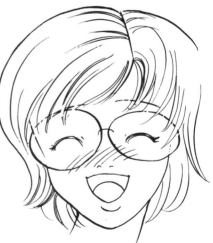

Sometimes more flavor can be added by drawing the outline of the glasses freehand.

75

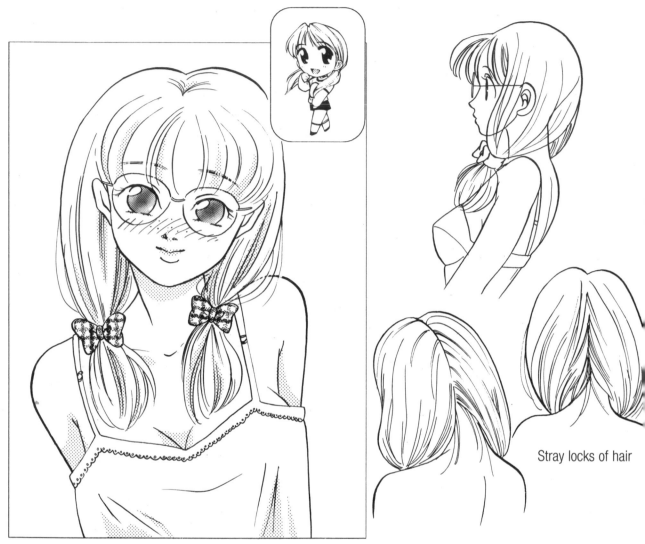

Combined with a babe with glasses look

Stray locks of hair

A wide range of variations can be created with the following devices: the length of the hair, how and where the hair is tied and whether or not the ears are exposed.

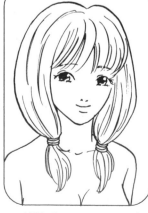

With the ears covered

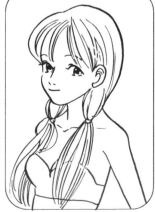

With longer hair

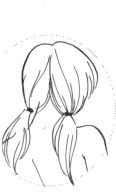

Back of the head view

Hair that flows in the back

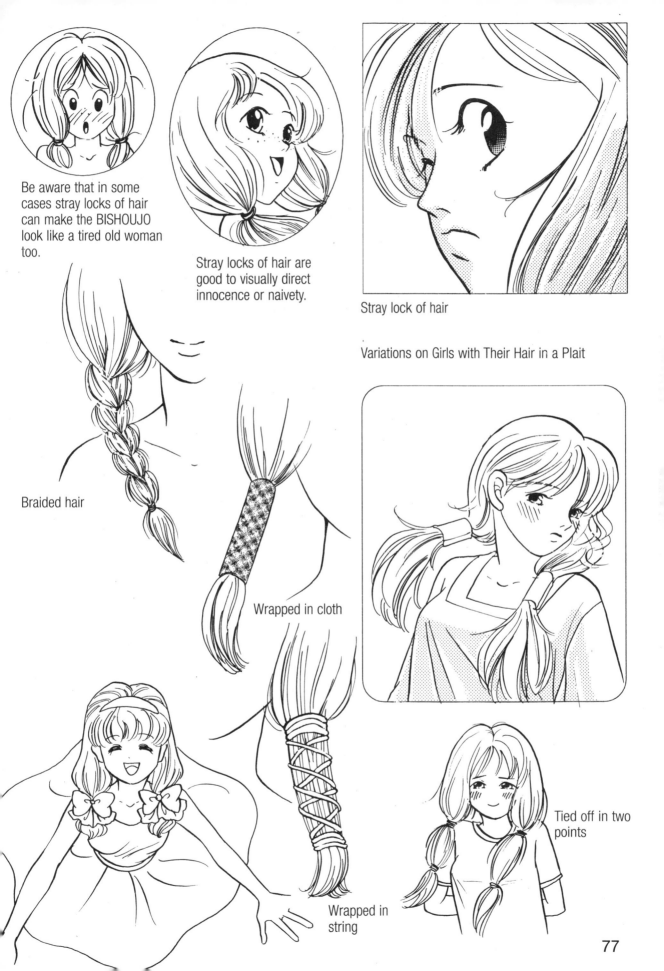

Be aware that in some cases stray locks of hair can make the BISHOUJO look like a tired old woman too.

Stray locks of hair are good to visually direct innocence or naivety.

Stray lock of hair

Variations on Girls with Their Hair in a Plait

Braided hair

Wrapped in cloth

Wrapped in string

Tied off in two points

Hairbands, Tiaras and Ribbons

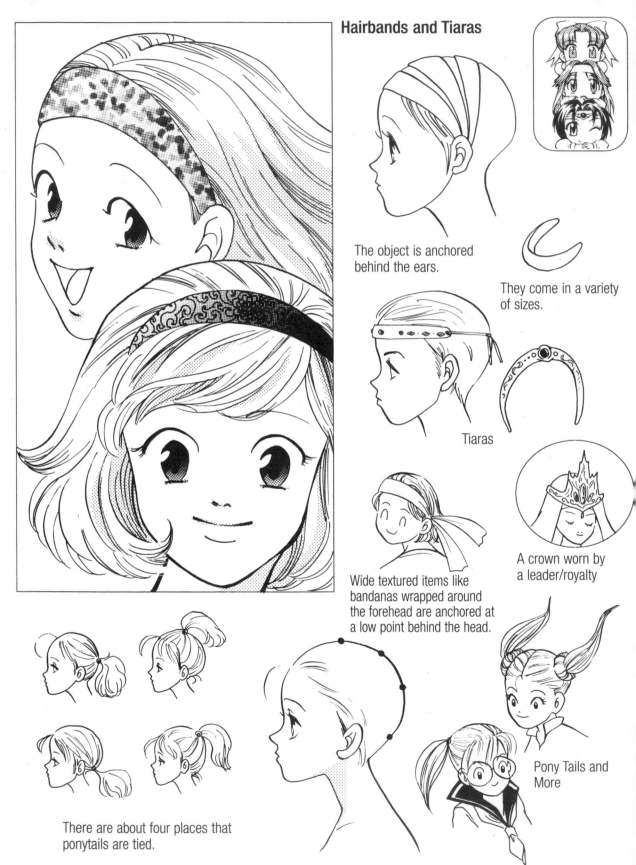

Hairbands and Tiaras

The object is anchored behind the ears.

They come in a variety of sizes.

Tiaras

A crown worn by a leader/royalty

Wide textured items like bandanas wrapped around the forehead are anchored at a low point behind the head.

Pony Tails and More

There are about four places that ponytails are tied.

Ribbon Principles

Ribbons add variation to tied up hair. Draw a ponytail then add a ribbon.

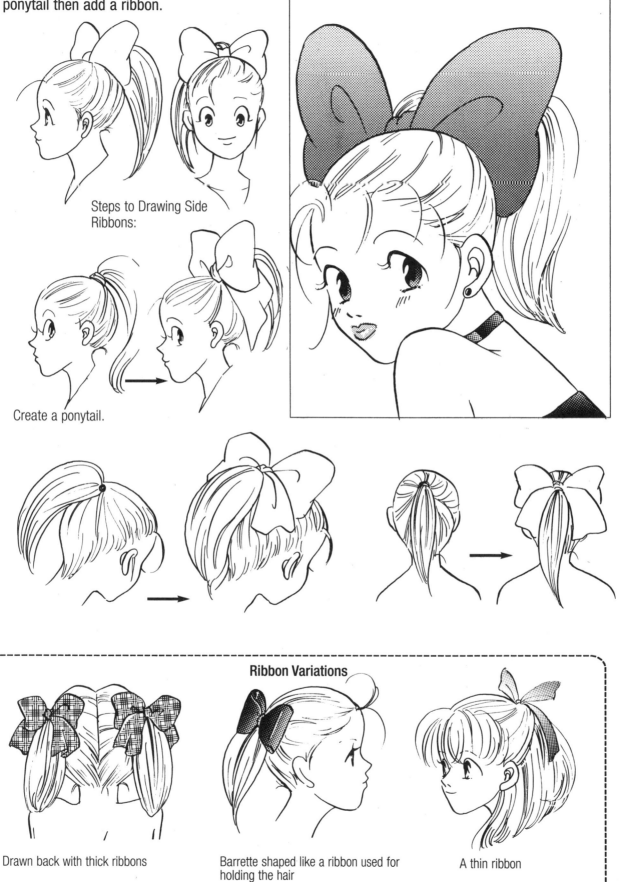

Steps to Drawing Side Ribbons:

Create a ponytail.

Ribbon Variations

Drawn back with thick ribbons

Barrette shaped like a ribbon used for holding the hair

A thin ribbon

Hats and Caps

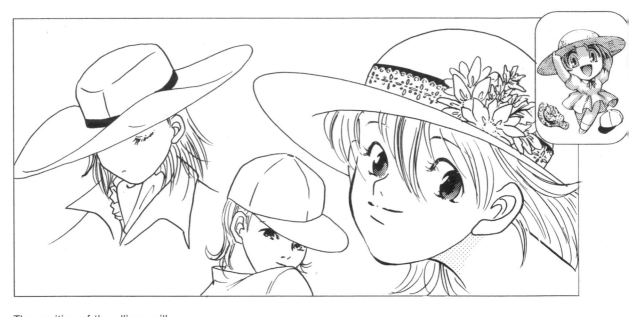

The position of the ellipse will change depending on how the hat is worn.

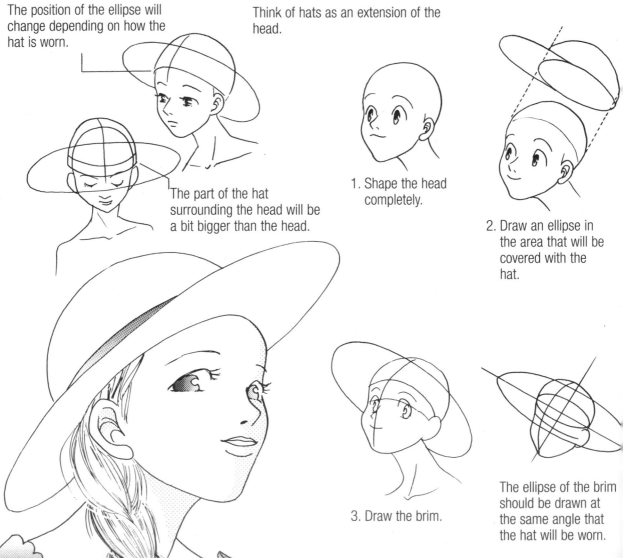

The part of the hat surrounding the head will be a bit bigger than the head.

Think of hats as an extension of the head.

1. Shape the head completely.

2. Draw an ellipse in the area that will be covered with the hat.

3. Draw the brim.

The ellipse of the brim should be drawn at the same angle that the hat will be worn.

Various Caps

Sun Shielding Hats

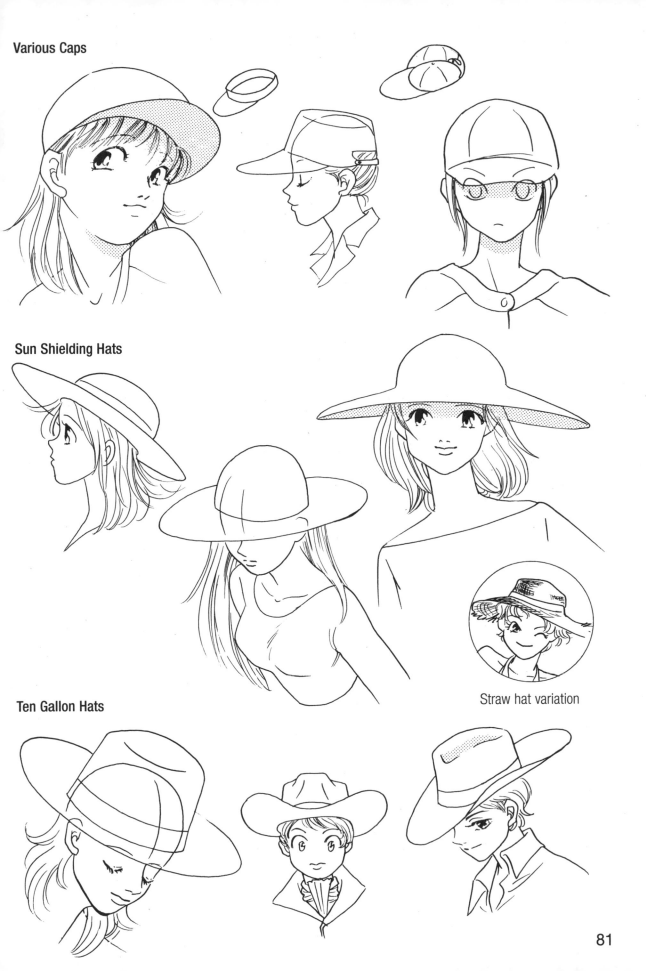

Straw hat variation

Ten Gallon Hats

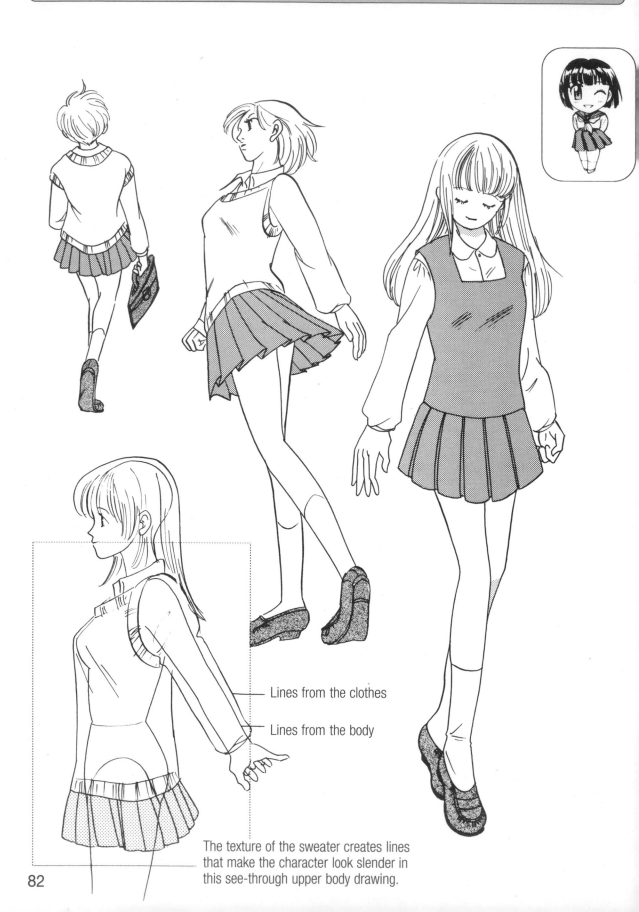

Lines from the clothes

Lines from the body

The texture of the sweater creates lines that make the character look slender in this see-through upper body drawing.

Other Typical School Uniforms

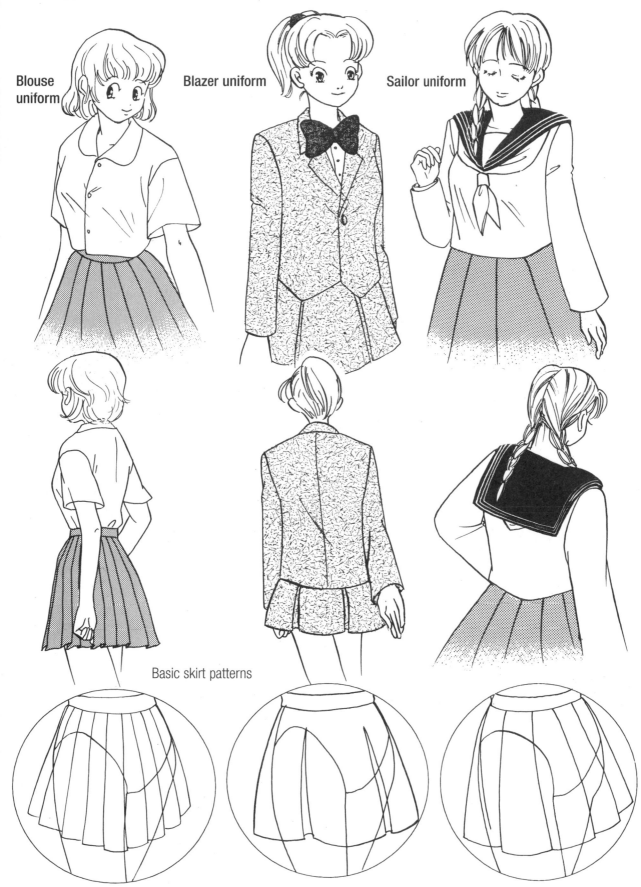

Blouse uniform

Blazer uniform

Sailor uniform

Basic skirt patterns

Maids

Variations to clothing worn by maids can be created by changing the length of the skirt and the shapes of the collar and sleeve band.

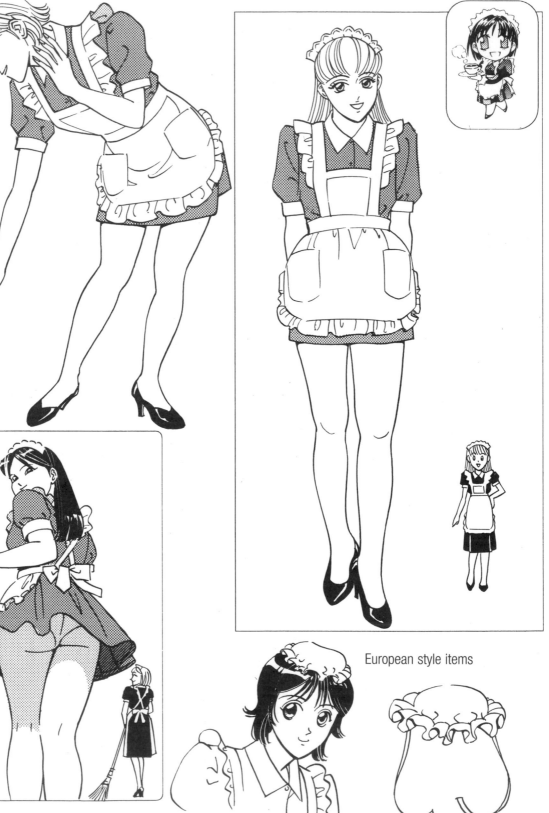

European style items

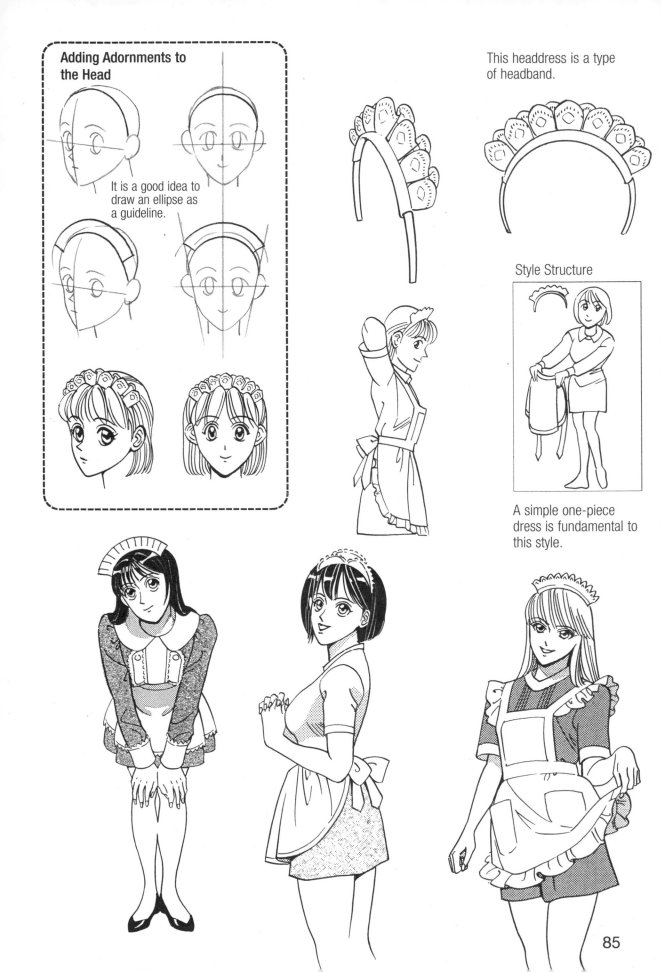

Adding Adornments to the Head

It is a good idea to draw an ellipse as a guideline.

This headdress is a type of headband.

Style Structure

A simple one-piece dress is fundamental to this style.

Bunny Girls

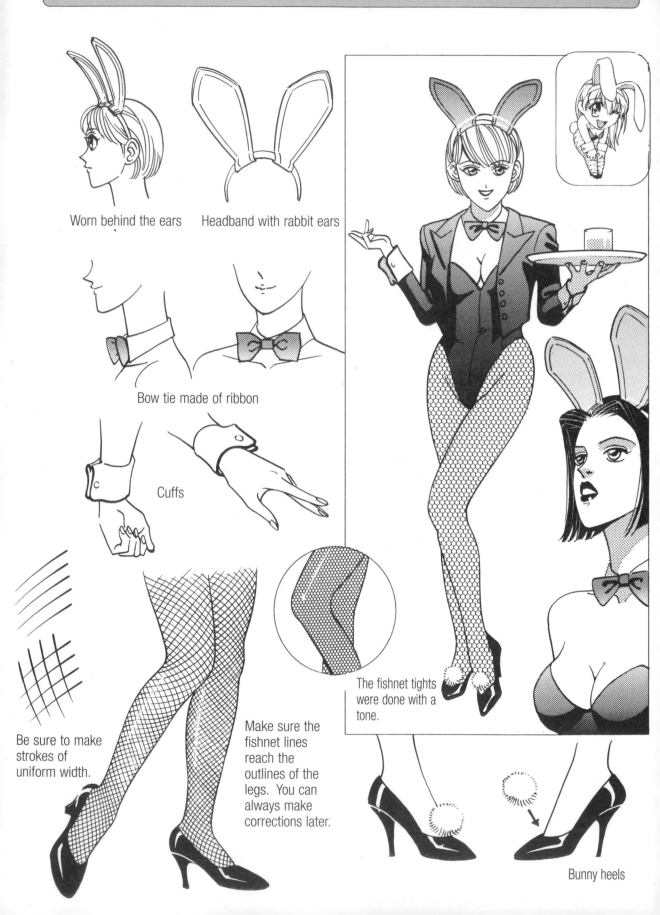

Worn behind the ears

Headband with rabbit ears

Bow tie made of ribbon

Cuffs

Be sure to make strokes of uniform width.

Make sure the fishnet lines reach the outlines of the legs. You can always make corrections later.

The fishnet tights were done with a tone.

Bunny heels

The ears point out at various angles.

The length of the ears should be just about, if not, a bit longer than the head.

Placing the position of the ears directly above the eyes is suitable.

Lately, smaller ears are popular.

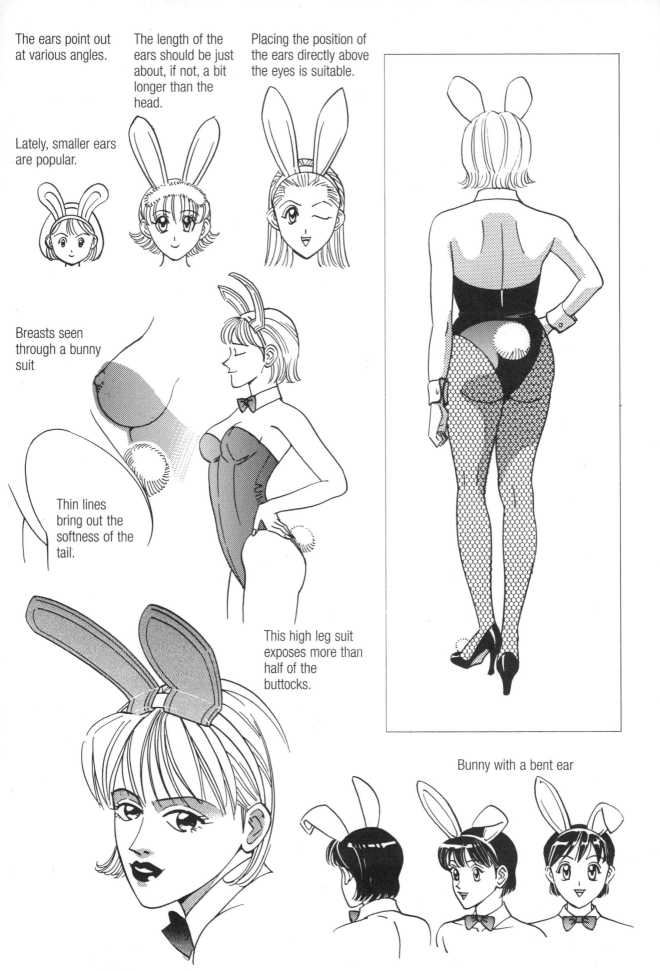

Breasts seen through a bunny suit

Thin lines bring out the softness of the tail.

This high leg suit exposes more than half of the buttocks.

Bunny with a bent ear

Nurses

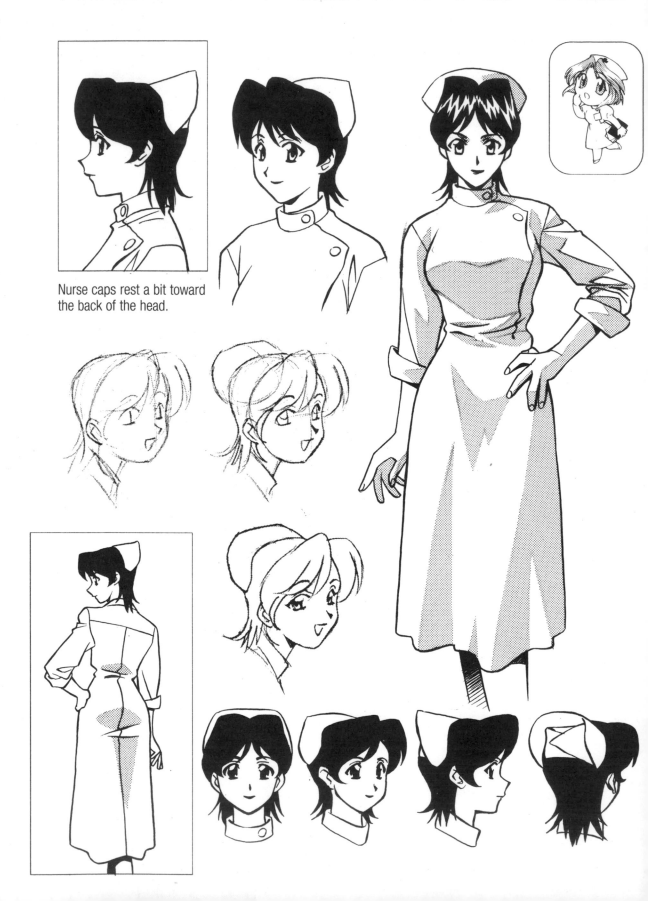

Nurse caps rest a bit toward the back of the head.

Maidens in the Service of Shinto Shrines

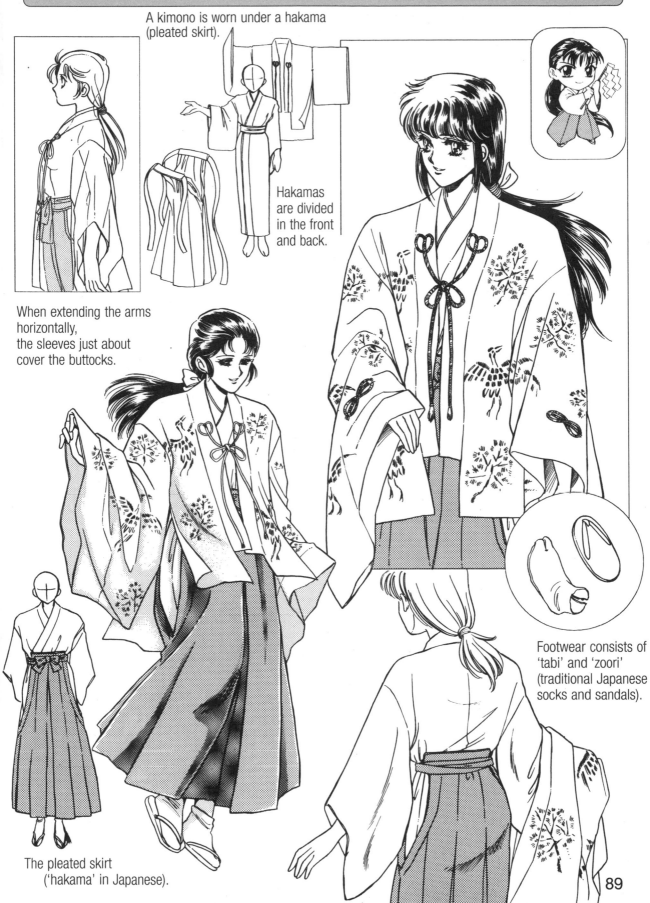

A kimono is worn under a hakama (pleated skirt).

Hakamas are divided in the front and back.

When extending the arms horizontally, the sleeves just about cover the buttocks.

Footwear consists of 'tabi' and 'zoori' (traditional Japanese socks and sandals).

The pleated skirt ('hakama' in Japanese).

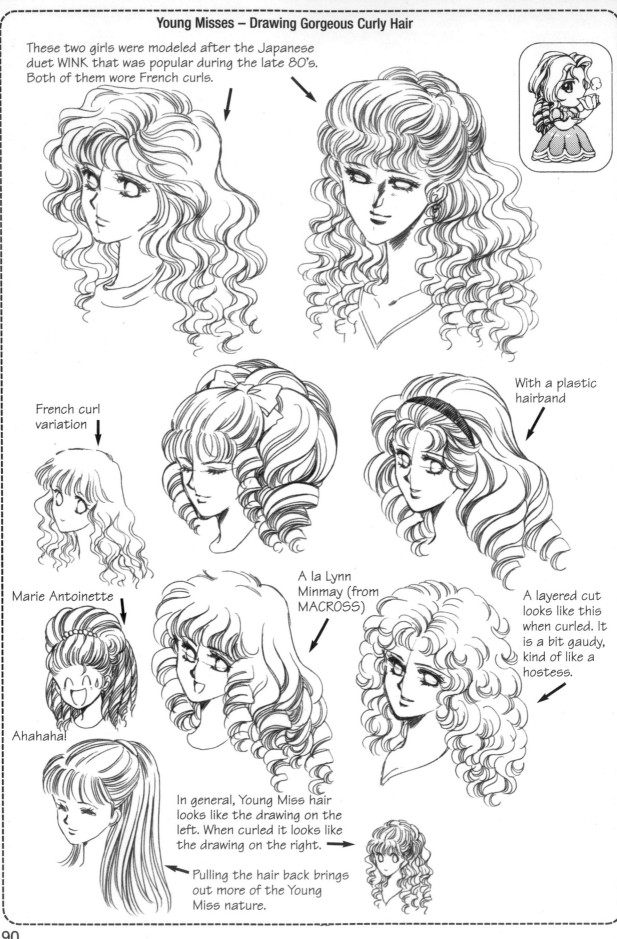

These two girls were modeled after the Japanese duet WINK that was popular during the late 80's. Both of them wore French curls.

French curl variation

With a plastic hairband

Marie Antoinette

A la Lynn Minmay (from MACROSS)

A layered cut looks like this when curled. It is a bit gaudy, kind of like a hostess.

Ahahaha!

In general, Young Miss hair looks like the drawing on the left. When curled it looks like the drawing on the right.

Pulling the hair back brings out more of the Young Miss nature.

Chapter 5

Out-Of-This-World BISHOUJO

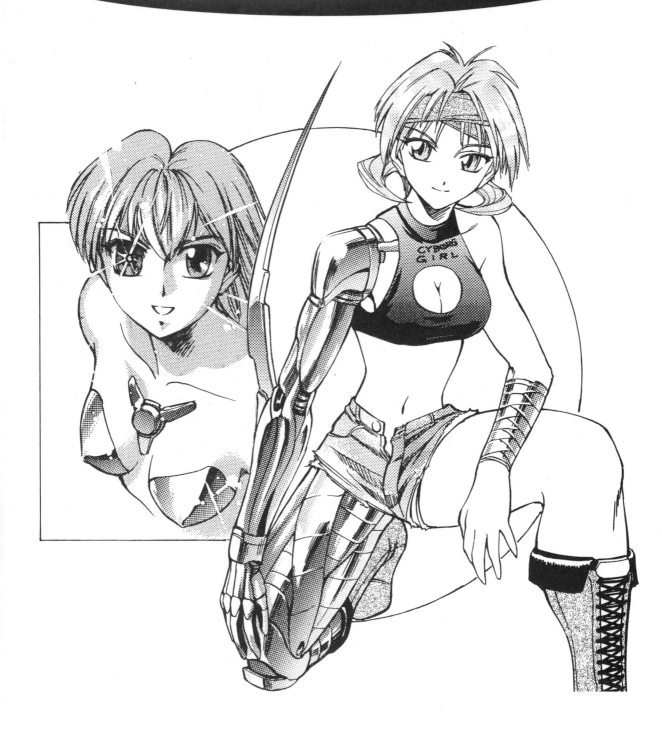

Cat Eared Lasses

A catlike gesture

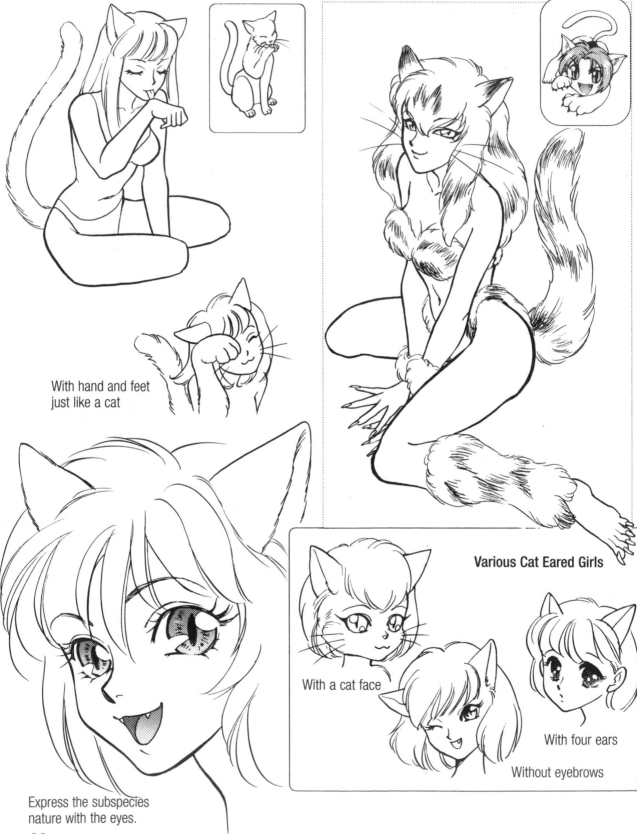

With hand and feet
just like a cat

Various Cat Eared Girls

With a cat face

With four ears

Without eyebrows

Express the subspecies
nature with the eyes.

Learn from actual cats to create cute moods and subspecies natures.

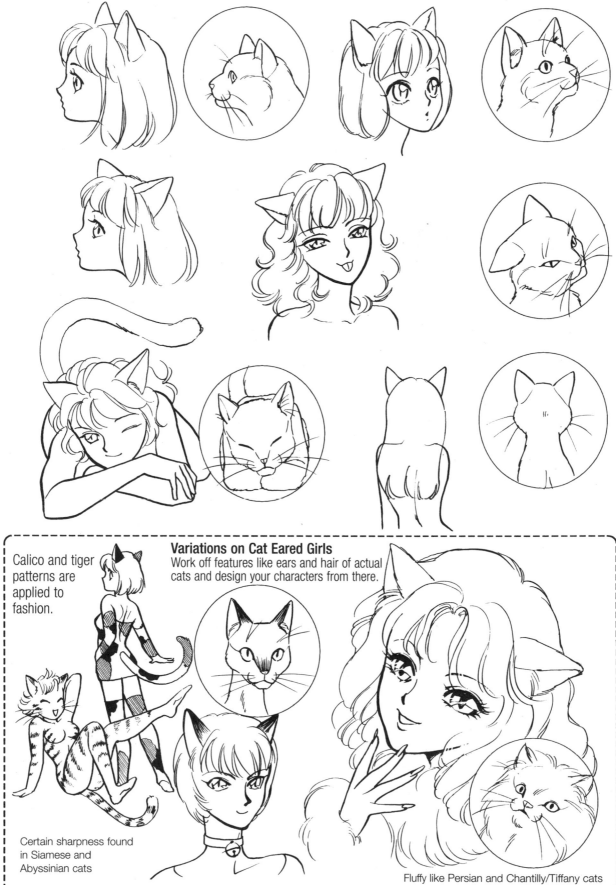

Variations on Cat Eared Girls
Work off features like ears and hair of actual cats and design your characters from there.

Calico and tiger patterns are applied to fashion.

Certain sharpness found in Siamese and Abyssinian cats

Fluffy like Persian and Chantilly/Tiffany cats

Girls in Fur

Animal ears and a tail are the telltale attributes of girls in fur.

Ears

Various ear placement

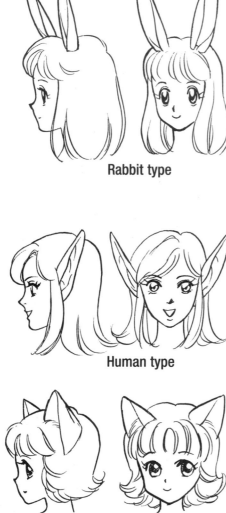

Rabbit type

Human type

Even with the same cat ears, the look changes with the size in comparison to the head.

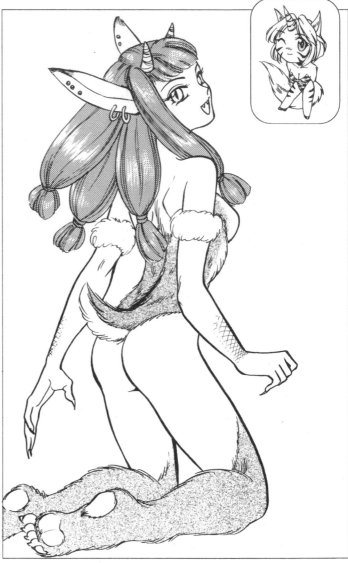

Studying the differences in the shapes of the ears depending on how they move or from the angle viewed increases the range of expression in visual direction and emotional state of the characters.

Deer, hares and others

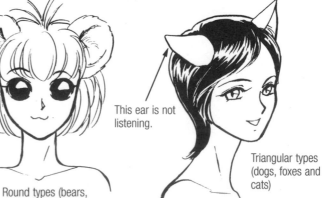

This ear is listening to something in the other direction.

This ear is not listening.

Round types (bears, mice and raccoons)

Triangular types (dogs, foxes and cats)

Easy Steps to Drawing Ears

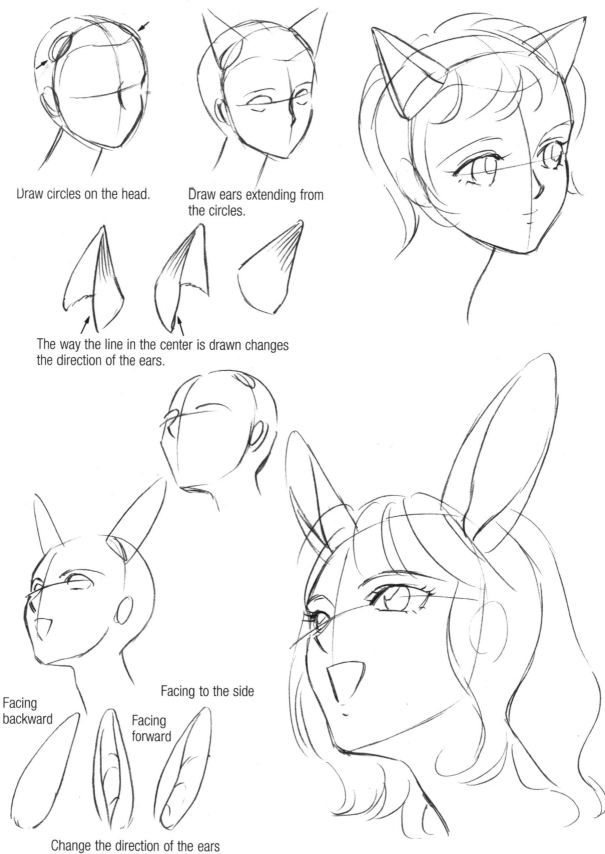

Draw circles on the head.

Draw ears extending from the circles.

The way the line in the center is drawn changes the direction of the ears.

Facing to the side

Facing backward

Facing forward

Change the direction of the ears as you see fit.

Tails

Tails, just like ears, are useful for expressing emotions. Apply actual animal tails in your design.

Simply extending the tail from the coccyx is pretty pedestrian. Let your likes and tastes take precedence.

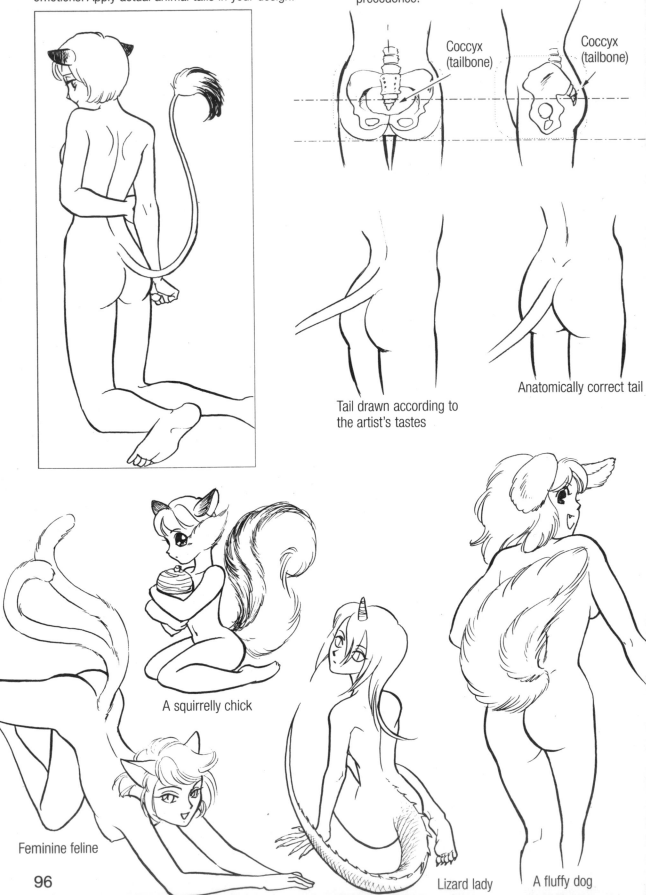

Coccyx (tailbone)

Coccyx (tailbone)

Tail drawn according to the artist's tastes

Anatomically correct tail

A squirrelly chick

Feminine feline

Lizard lady

A fluffy dog

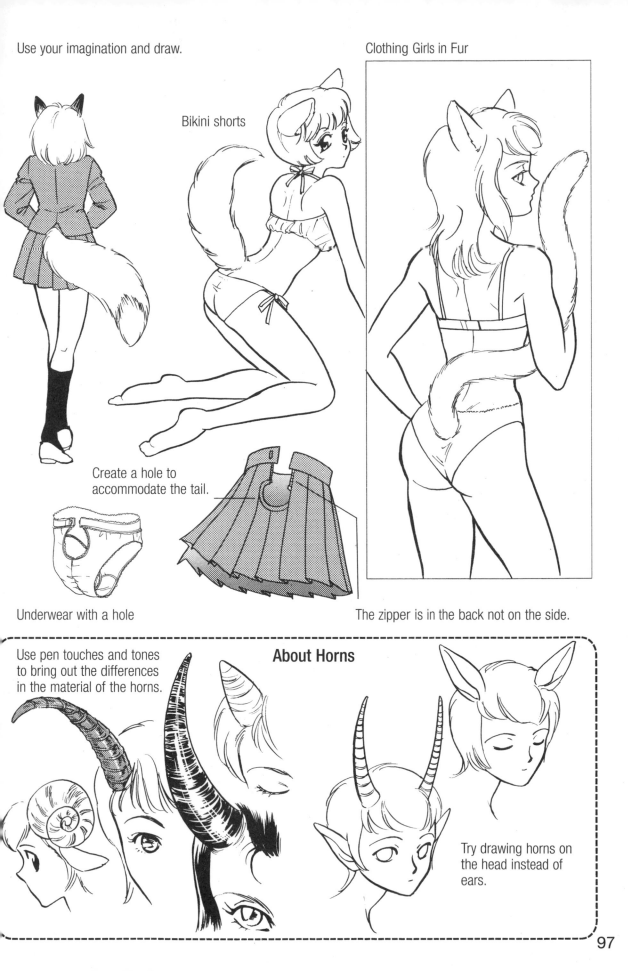

Use your imagination and draw.

Clothing Girls in Fur

Bikini shorts

Create a hole to accommodate the tail.

Underwear with a hole

The zipper is in the back not on the side.

Use pen touches and tones to bring out the differences in the material of the horns.

About Horns

Try drawing horns on the head instead of ears.

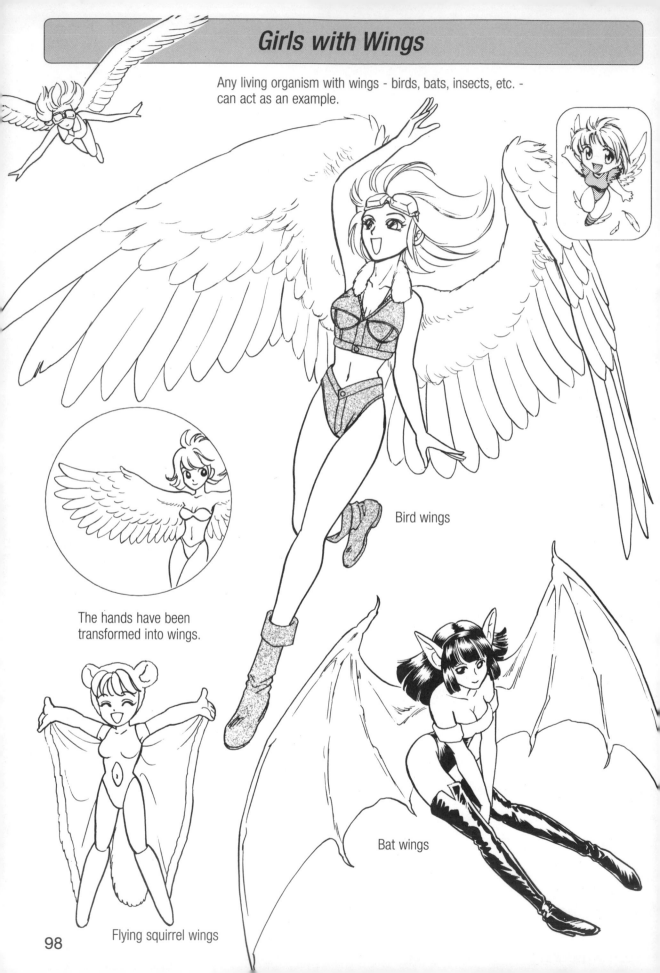

Girls with Wings

Any living organism with wings - birds, bats, insects, etc. - can act as an example.

Bird wings

The hands have been transformed into wings.

Bat wings

Flying squirrel wings

Structurally, wings operate like hands.

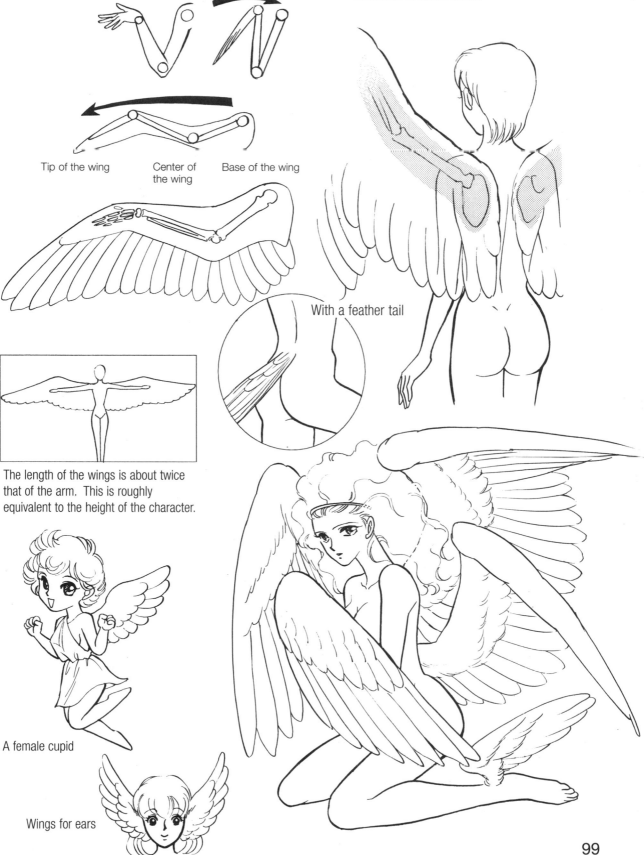

Tip of the wing

Center of the wing

Base of the wing

With a feather tail

The length of the wings is about twice that of the arm. This is roughly equivalent to the height of the character.

A female cupid

Wings for ears

Bird Wing Principles

The wings often grow from the shoulder blade similar to the skeletal structure of actual birds.

Wings – Front and Back

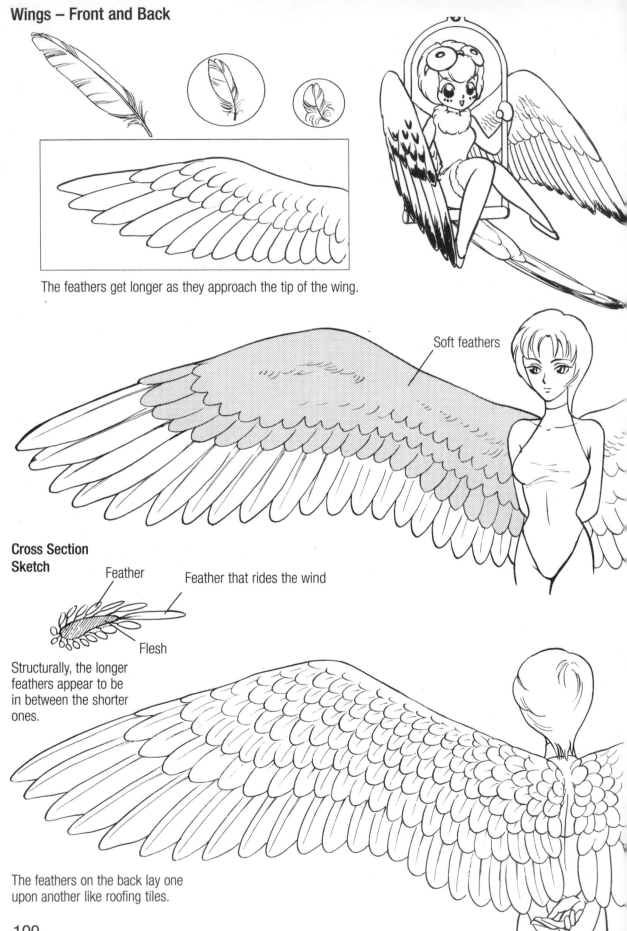

The feathers get longer as they approach the tip of the wing.

Soft feathers

Cross Section Sketch

Feather

Feather that rides the wind

Flesh

Structurally, the longer feathers appear to be in between the shorter ones.

The feathers on the back lay one upon another like roofing tiles.

Folding the Wings The silhouette changes depending on how the wings are folded.

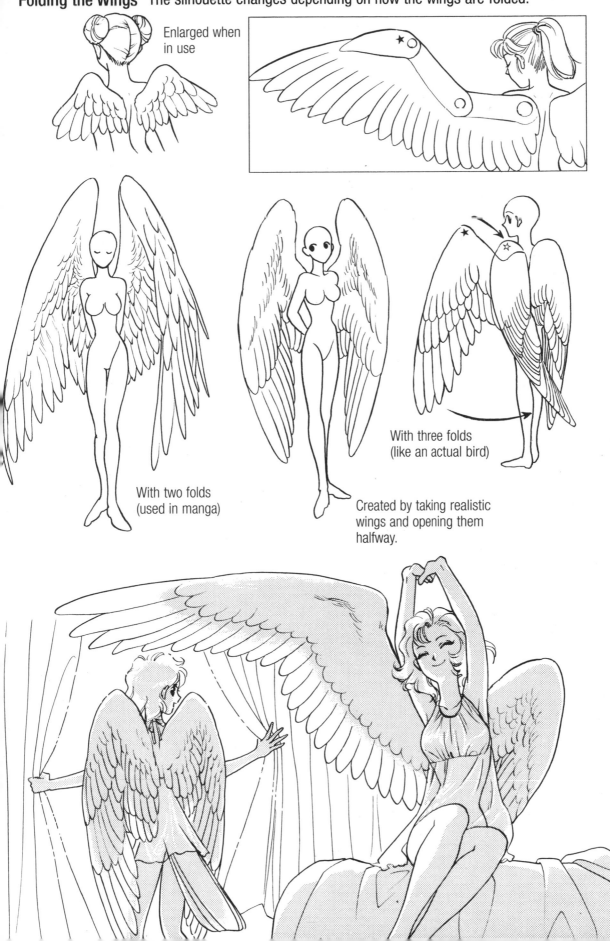

Enlarged when in use

With two folds (used in manga)

With three folds (like an actual bird)

Created by taking realistic wings and opening them halfway.

Mermaids

Bring out the originality in your mermaids in the area below the waist that has been transformed into a fish.

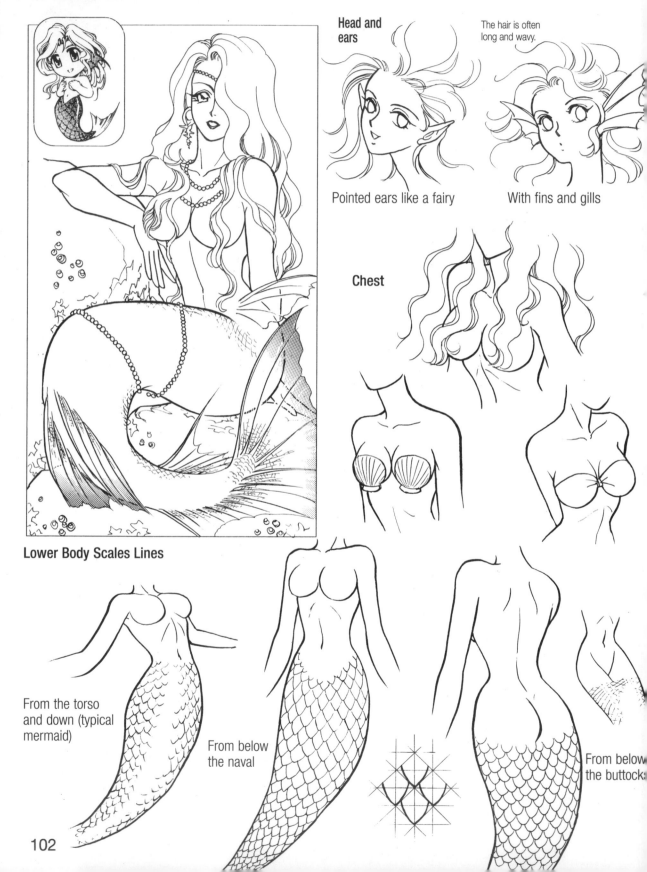

Head and ears

The hair is often long and wavy.

Pointed ears like a fairy

With fins and gills

Chest

Lower Body Scales Lines

From the torso and down (typical mermaid)

From below the naval

From below the buttocks

Concerning Tails

Since mermaids are girls with tails for legs, the length of the tail is about the same as the legs.

Various Tails

Sweetfish and crucian carp

Bream and killifish

Sea bass and loach

Bonito and marlin

Whales and dolphins

Horizontal fin type

Vertical fin type

A human upper body is rarely interchanged with just the head of the fish; however, it does happen sometimes.

Pointed ears and insect wings make up the basics.

Pointed Ears

The basic design is taken from human ears.

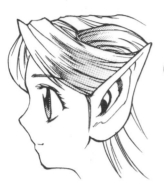

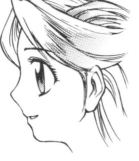

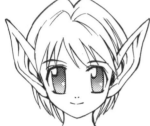

With large ears

With small ears

With wide ears

With big, wide ears

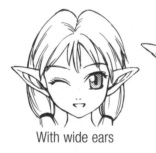

Expressions Using Wide Ears

Think of wide ears as normal ears that have overgrown.

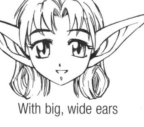

Pointed Ears and Their Appearance

Standard girl with pointed ears

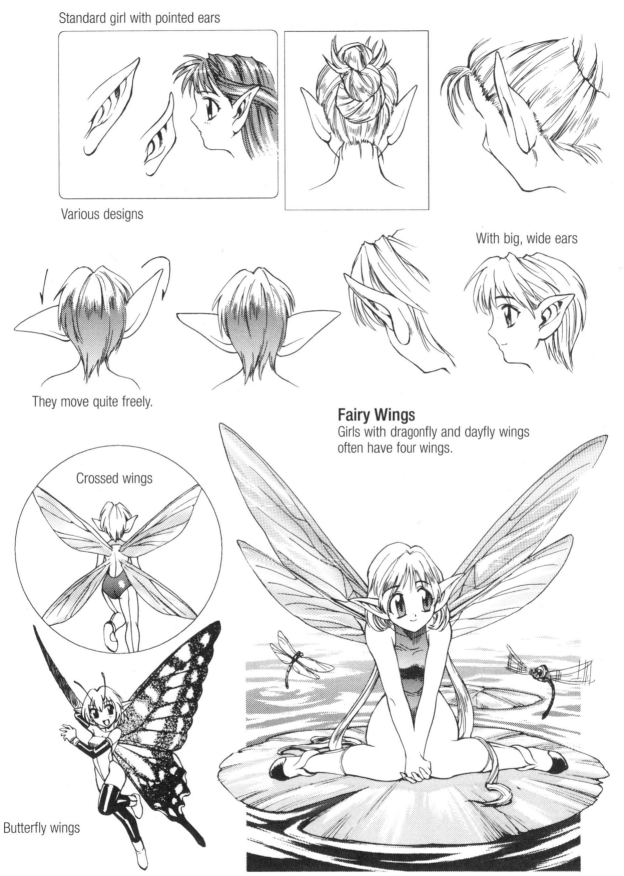

Various designs

They move quite freely.

With big, wide ears

Fairy Wings
Girls with dragonfly and dayfly wings often have four wings.

Crossed wings

Butterfly wings

Hoods and Cloaks

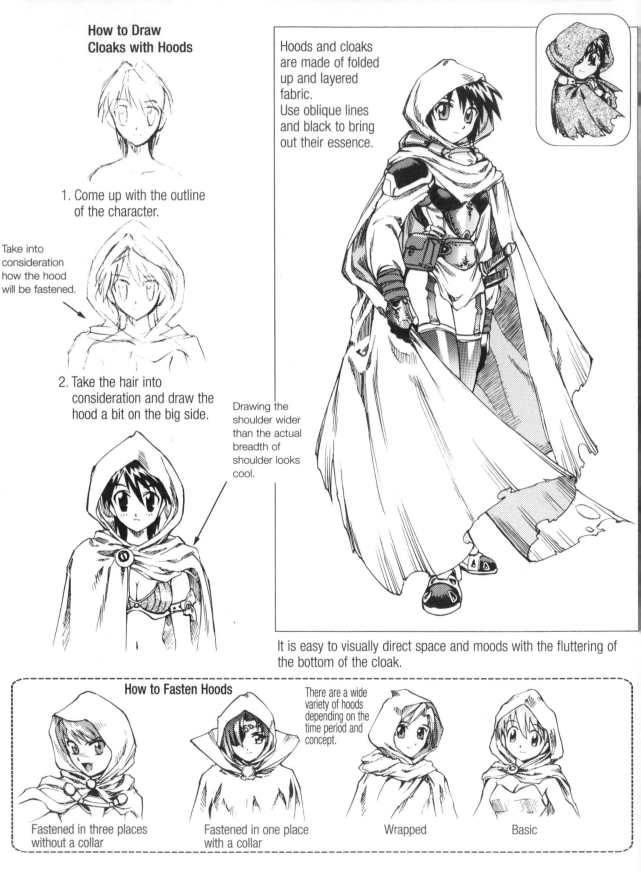

How to Draw Cloaks with Hoods

1. Come up with the outline of the character.

Take into consideration how the hood will be fastened.

2. Take the hair into consideration and draw the hood a bit on the big side.

Drawing the shoulder wider than the actual breadth of shoulder looks cool.

Hoods and cloaks are made of folded up and layered fabric. Use oblique lines and black to bring out their essence.

It is easy to visually direct space and moods with the fluttering of the bottom of the cloak.

How to Fasten Hoods

There are a wide variety of hoods depending on the time period and concept.

Fastened in three places without a collar

Fastened in one place with a collar

Wrapped

Basic

A covert look

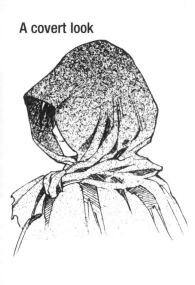

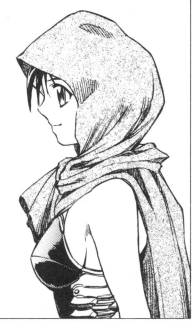

Wearing just the hood with the cloak draped over the back exposing the arms.

With the hood pulled back

The size of the fluttering part of the cloak is a matter of taste. The bottom is sometimes expressed as tattered.

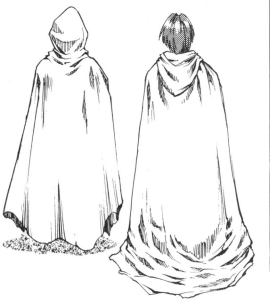

Two types of hooded cloaks exist. The difference is the length of the trains.

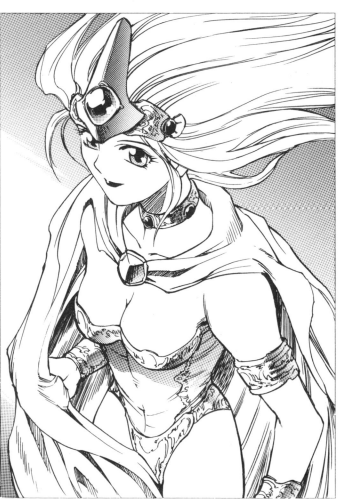

Powered Suits

Reinforced armored suits are sometimes known as powered suits. Think of them as metallic tinted costumes.

Various Parts

Helmet

Face guard

Shoulder armor

Body armor

Shin armor

Arm guard

A slew of parts and names exist depending on the artist.

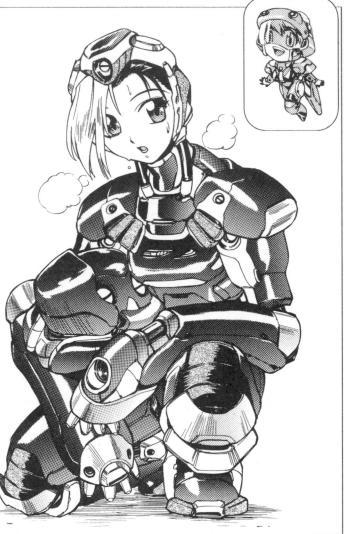

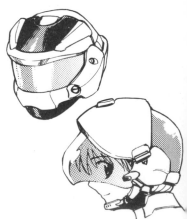

Types of Armor

PHHISST!

BRRRR!

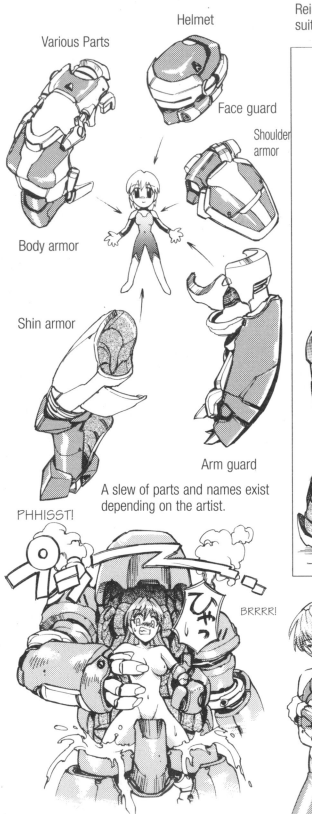

A lot of times the underwear is foregone and the nude body is placed inside things like shock absorbing liquid or a delicate electromagnetic coating.

Creating functional underwear worn under the armor is also important.

This is a full-face guard type helmet that conceals the face. Make reference of actual helmets used with motorcycles and combat aircraft.

Robot Type

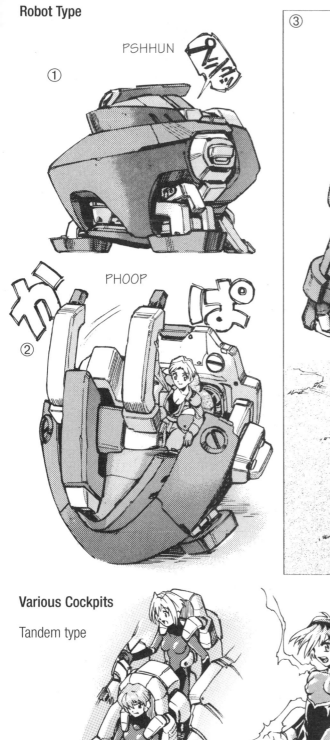

① PSHHUN

② PHOOP

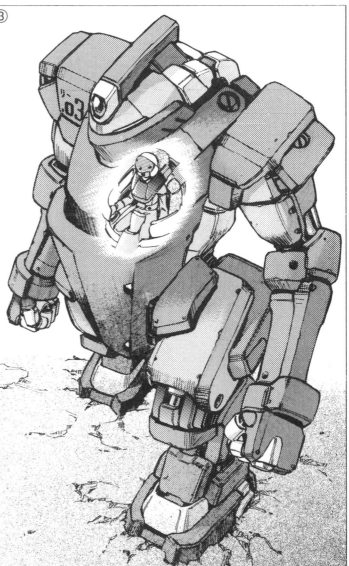

③

Various Cockpits

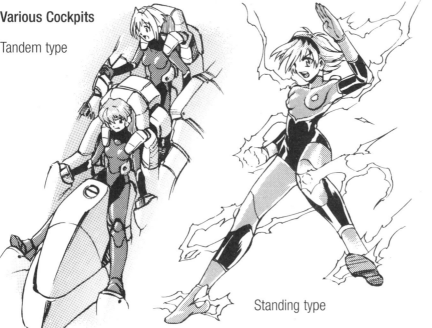

Tandem type

Standing type

One passenger type

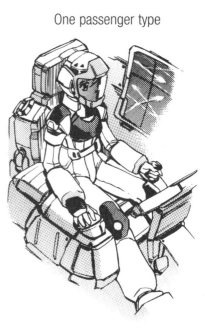

Bionic Cyborg Girls

Classical robot style

Camera eye

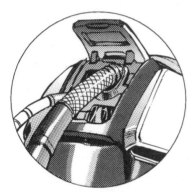

A functional cord and pipe

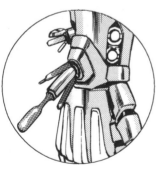

Various types of sensors

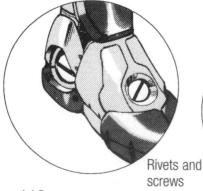

Rivets and screws

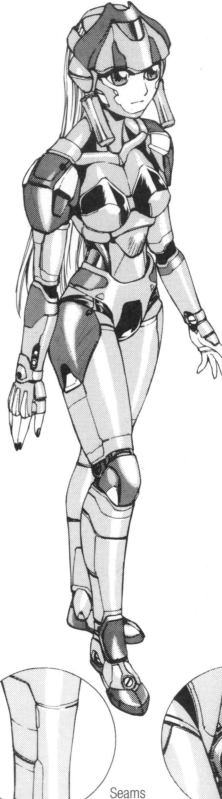

Use anything and everything to bring out the mechanical nature. While periodic trends exist in their design, allow your tastes to take precedence.

Moving parts drawn exposing delicate items on the inside.

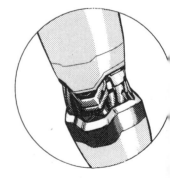

Seams

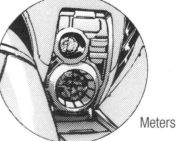

Meters

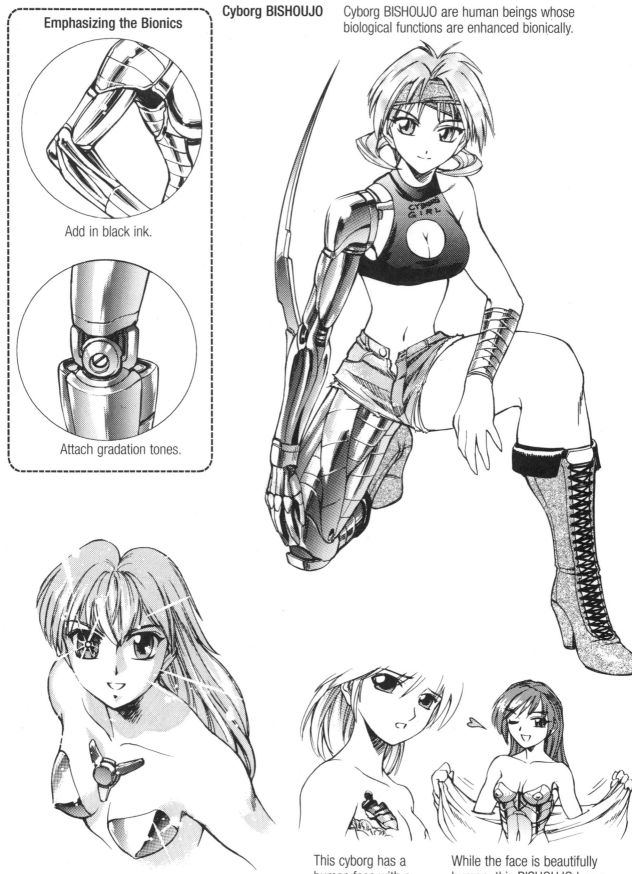

Emphasizing the Bionics

Add in black ink.

Attach gradation tones.

Cyborg BISHOUJO Cyborg BISHOUJO are human beings whose biological functions are enhanced bionically.

The visual direction emphasizes her bionic eye.

This cyborg has a human face with a wound revealing the bionics.

While the face is beautifully human, this BISHOUJO bears her bionics when she takes off her clothes.

Drawing Tiny Tot Characters

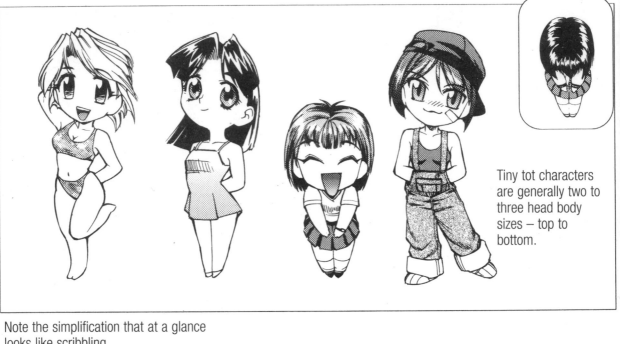

Tiny tot characters are generally two to three head body sizes – top to bottom.

Note the simplification that at a glance looks like scribbling.

With normally balanced hands and feet

With small hands and feet

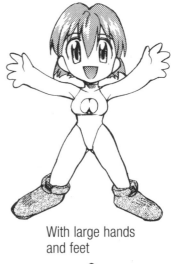

With large hands and feet

The tips of the hands and feet are round and thick.

The tips of the hands and feet are finely deformed.

The hands and feet are well deformed.

① Establish the sphere of the drawing.

② Draw two to three heads to act as yardsticks for balance.

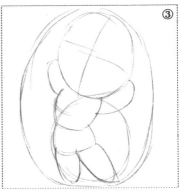

③ Give shape to a rough pose.

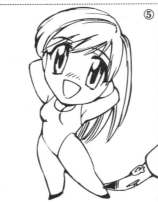

④ Draw in the details.

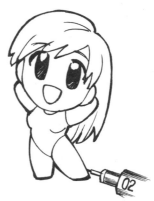

⑤ Simplify the hair, pose and clothing even further.

Turning Normal Characters into Tiny Tots

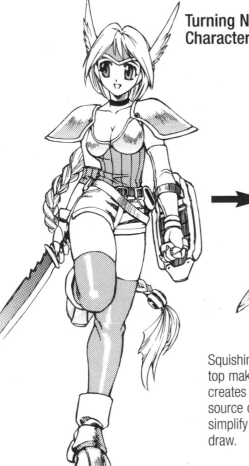

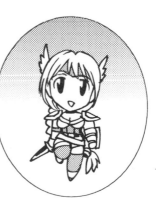

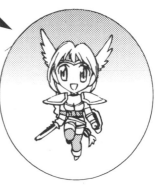

Squishing the character from the top making the overall body round creates tiny tots. When you have a source drawing to work off of, simplify the detailed areas and draw.

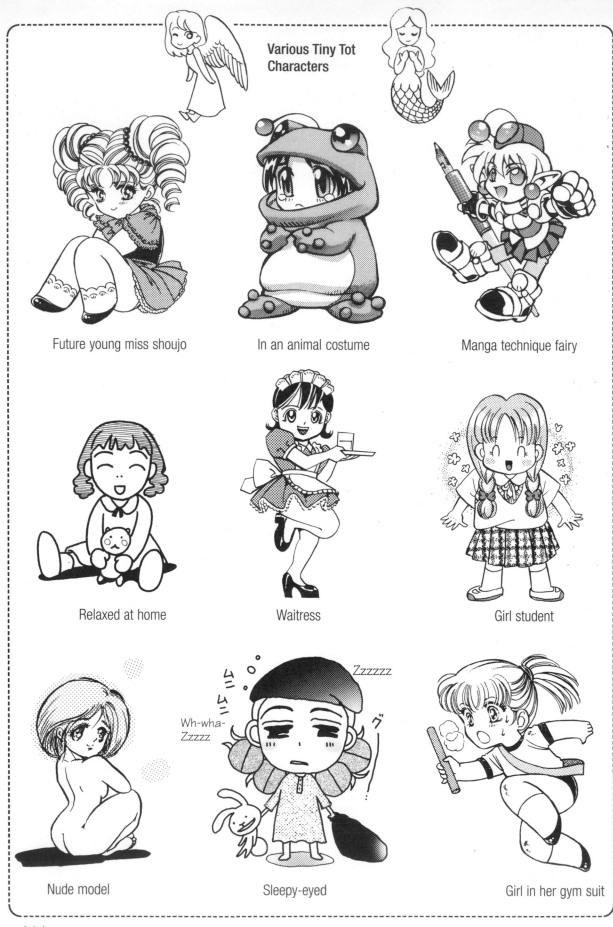

Various Tiny Tot Characters

Future young miss shoujo

In an animal costume

Manga technique fairy

Relaxed at home

Waitress

Girl student

Nude model

Sleepy-eyed

Girl in her gym suit

Chapter 6

Learn From the Masters
Manga Artist Case Study Techniques

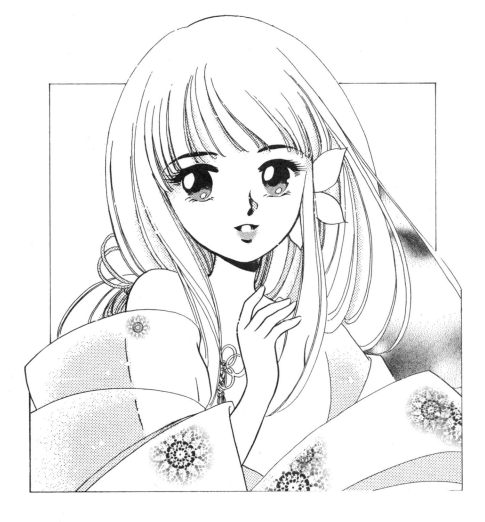

BISHOUJO
by Eimu Mizuki

The red on the face is for visually directing embarrassment and surprise and is expressed with detailed, forceful lines and tones. Using pen touches and tones together effectively creates a big impact.

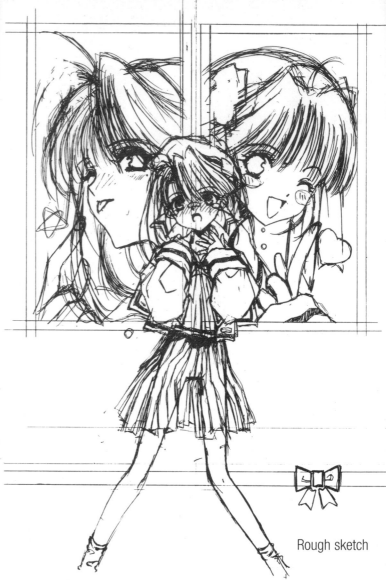

Rough sketch

It is important to have a vision for the finished image from the beginning of your rough sketches as shown above.

Slender Legs - The Key to Girls of Delicate Constitution

All three types of BISHOUJO subject matter - childish, girlish and somewhat adult - have been included in this simple composition.

Don't just line them up and draw. After all, this is manga. When you want to draw these three types, maximize the appeal and true charm of manga by creating a composition that has dramatic visual direction possibilities that bring about a premonition in the story.

The action of a girl taken back can be visually directed by adding in innocent poses and expressions with the movement of the hair. In addition, the conclusive factors to visually directing this girlish nonchalant style are the not-too-big pelvis and thin legs.

The bold, thick frame lines are also effective. Slightly covering the frame with big, dotted tones leaves a strong impact while giving the work a pop impression.

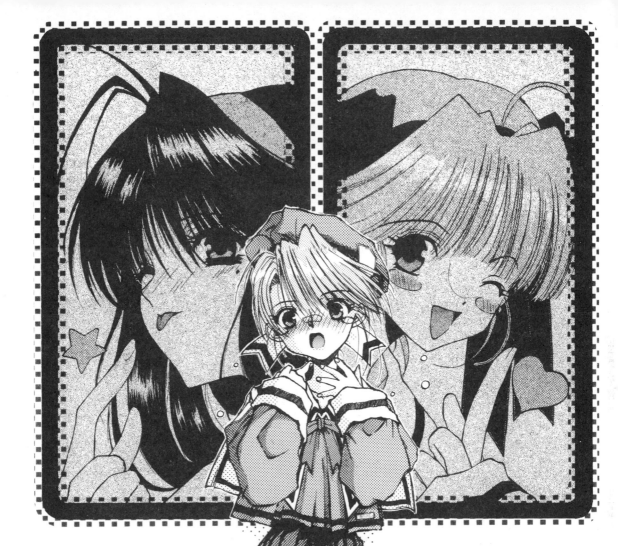

:YAMATONADESHIKO NO KOKOROE:

ICE FAIRY
by Tomoko Taniguchi

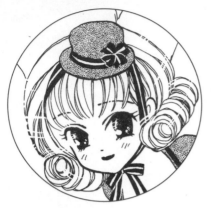

Using white is a basic visual direction technique for light and brightness. Adding just a little bit of white over the inked in areas is effective.

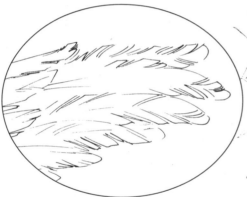

The softness and fluffy look in the wings are brought out with thin, sharp lines. A round pen was used here.

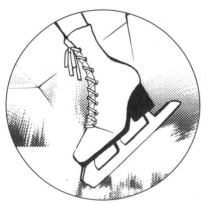

Drawing insteps of the feet with smooth lines brings about a sexy line. Form a picture in your head of the beautiful feet inside the skates and draw from there.

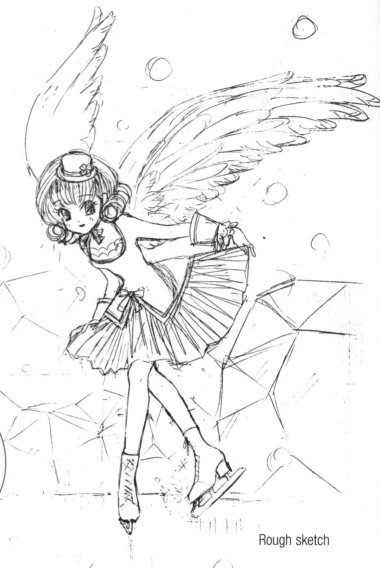

Rough sketch

The Short Body and Red Rouge Visually Direct the Cute Girlish Nature

Large eyes and a small mouth are classical elements to the traditional BISHOUJO style.
A small well-shaped mouth with a bit of red rouge helps to visually direct the coquettish shyness. In addition, the work gives off an impression of neat and clean pre-adolescent girlishness from drawing the torso a little on the short side relative to the head and the simple distinctions in the bodylines.

The soft wings create a feeling of fantasy while the elegantly drawn skates add something more to the character. Making use of props is one method for creating a mood of fantasy in your scenes.

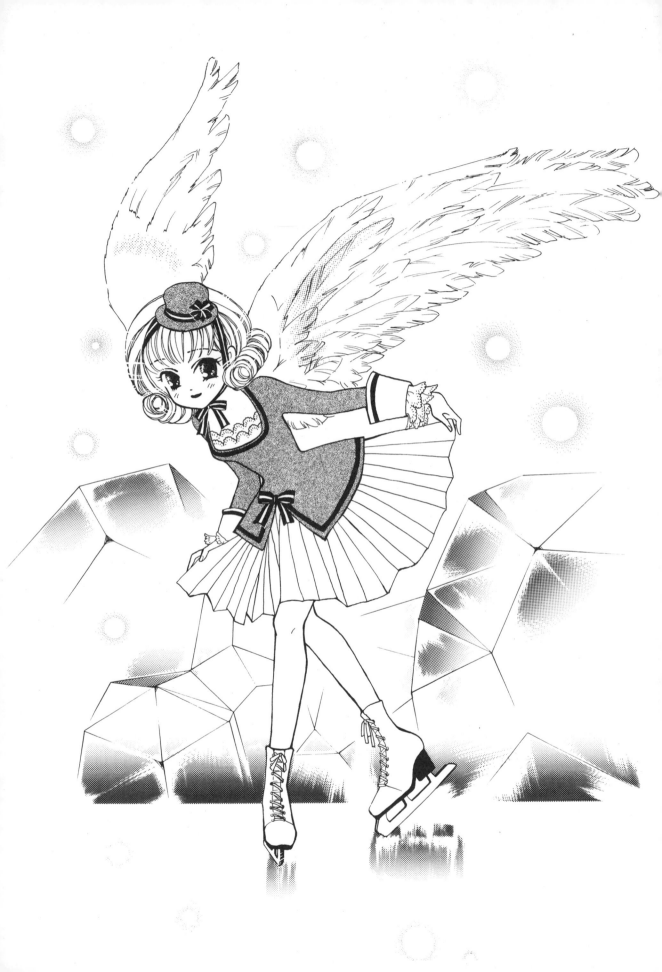

CONTRAST

by Kaoru Kawakata

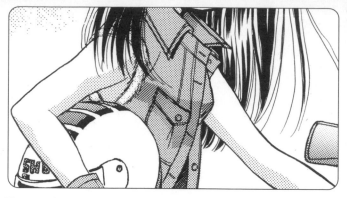

The tough texture of the loosely worn jacket, which does not openly show the bodyline, is expressed in the way the jacket is worn.Also, notice the differences in the thickness of the lines in places like the stitching on the clothing.

Eyes that gaze at the reader are one of the secret principles to drawing BISHOUJO.

The inorganic tone of the motorcycle and jacket emphasizes the whiteness and softness of the thighs giving the girl a healthy sense of well-being.

Take a look at these carefully drawn boots. The dirt expressed on the heel and the tip of the toe nonchalantly adds three-dimensionality and a sense of existence.

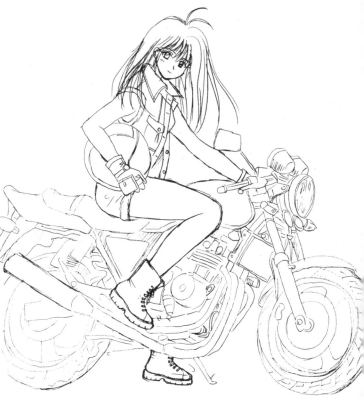

Rough sketch

The Mechanical Qualities Enhance the Girl's Softness and Radiance

The combination of the motorcycle and the girl is one technique for better showing her attractive nature. The hard, cold metal surface is completely opposite to the soft and warm qualities of the girl. This contrast doubles her naturally healthy appeal. Moreover, concealing the flow of the bodyline with the loose fitting jacket serves to highlight the beauty of the flesh and her shapely limbs. The appeal of the sleeveless jacket and shorts alone would have not been enough to create such an impact in this drawing.

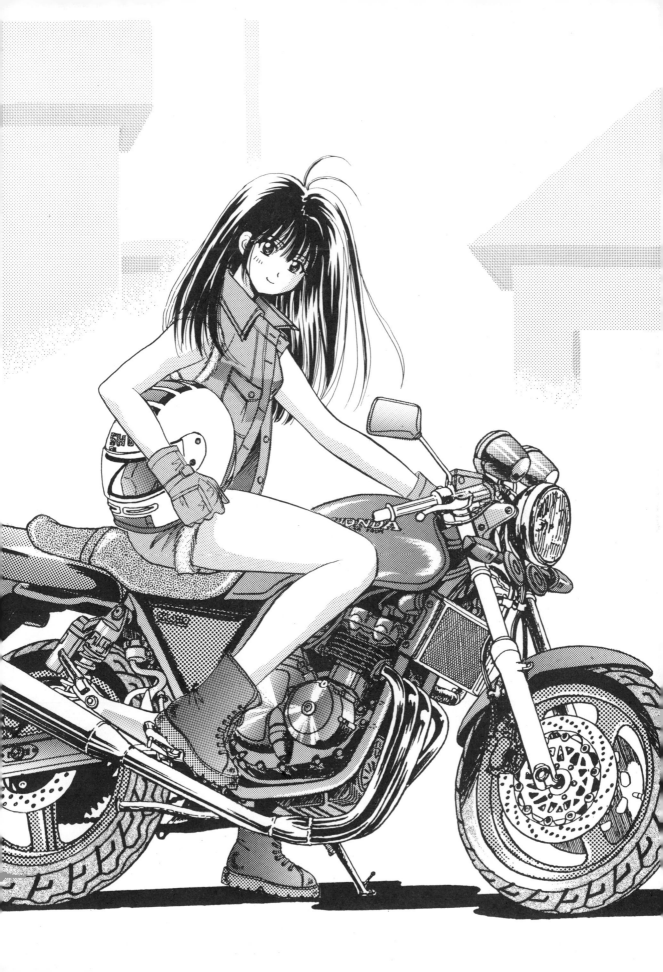

DOUBLE WAITRESS

by Kouichi Kusano

Note the detailed tone on the lower lip, which was created by over attaching the tone and etching. Making one part white brings out the three-dimensionality of the light and lips.

The sexy swelling of the muscle between the shin and the thigh is created when the heel of the bent leg almost touches the buttocks. When expressed using tones, the attractive flesh of the legs is manifested.

Rough sketch

The wrinkles show the tight fitting nature of the skirt. The angles of the curved lines indicate the three-dimensionality of the buttocks.
At the inking stage, keep from drawing the girl in back too much and focus on the girl in front.

Using Lines and Shadows to Bring out Character Personalities

The drawing is based on the frame of the characters. Notice the artist's varying pen touches in the hair, face, limbs, curves of the trays, cups and glasses. While accent lines are often thought to be 'old school', since they are drawn fine and sharp here, they can become refreshing. The use of relatively straight lines on the clothing serves to bring out its inorganic nature thereby separating it from the flesh. By varying the lines of the hair from the body parts, it conveys the rustling nature of the supple hair all the more. The individual accents of the lines (thick, thin and contrasting) create quite an impression by giving life and strength to the characters.

Note that the body and arms in relation to the bust are drawn with the least amount of necessary lines. This can only be drawn after firmly grasping an image of the structure of the body.

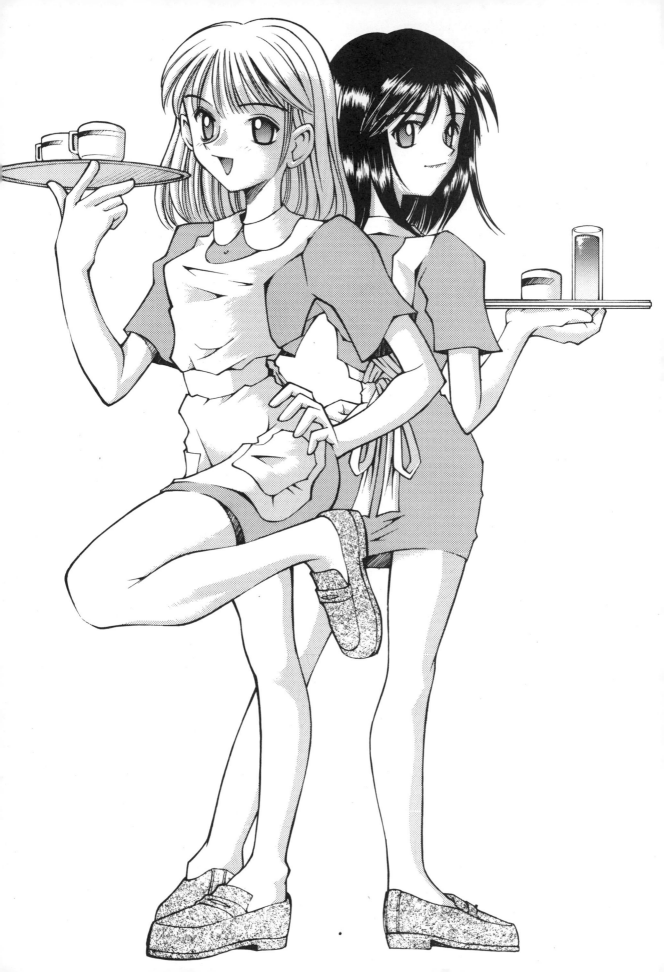

The hairstyle barely touching the eyeline easily conveys a gentle and elegant impression while the sporadic breeze and the soft, curved lines bring out a sense of quietness amid the motion.

Rough sketch

Adding some width between the outline of the clothing and the interior lines of the arms accents the relaxed nature of the clothing. Etching and shading off a tone just barely applied to the outer arm increases the see-through nature of the costume.

Bringing Out Transparency and Fantasy with Tone Management, Character and Motifs

The thin lines from a round pen and the tones that keep the drawing from looking flat create a synergetic effect on the serenity of the gently flowing hair. The softness of the hair comes out due to the fact that the tones have not been thickly applied and the parts that do not touch the lines have been neatly etched and gradated. The flower motif are slanted and arranged in accordance with the diagonal lines in the scene. The balance of the flower in the character's left ear visually directs a peculiar spatial sense of transparency. The white and black parts of the sketch tone have also been chosen effectively and a mood of fantasy has been brought out all the more with the arrangement.

124

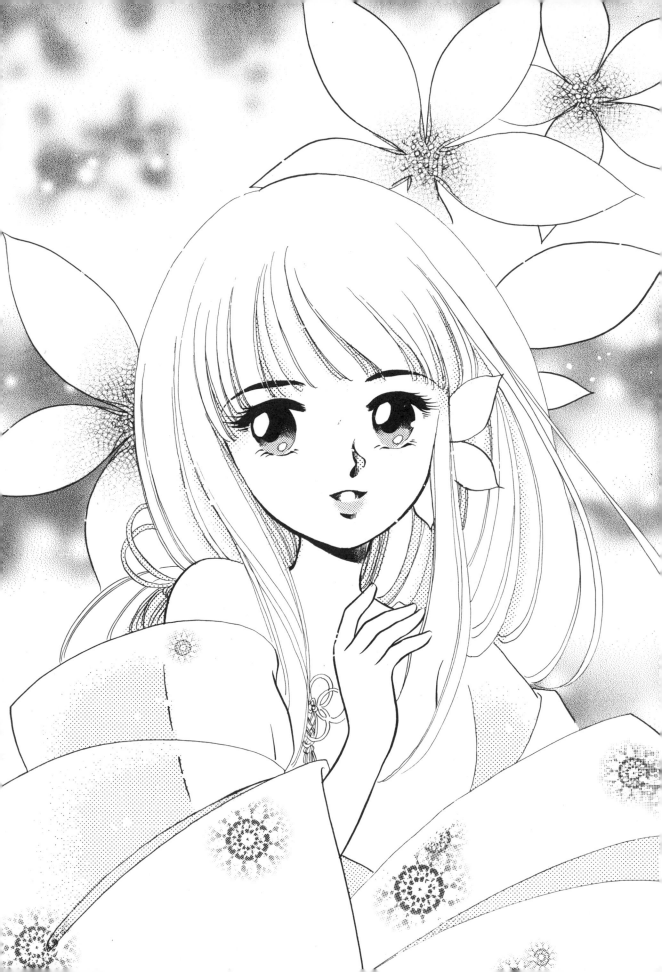

FEMALE STUDENT (JOGAKUSEI)

by Ganmma Suzuki

The sunlight shines from almost directly above and the hair hangs to the side.

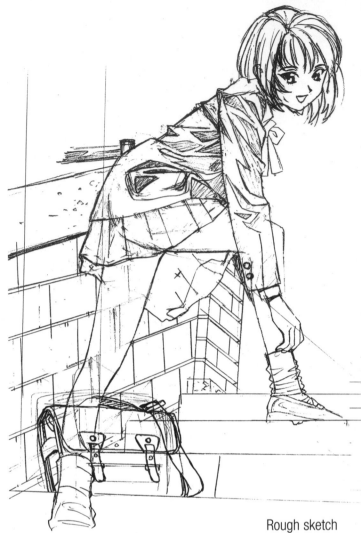

Rough sketch

The shapely, healthy legs are drawn with sharp lines. The scattered light is visually directed by flinging white. Also, the wrinkles in the skirt have been coated with a tone instead of being drawn.

A Calculated Contrast in the Scene Increases the Character's Presence

The calculated scene composition and tone management effectively show off the charm and presence of the character. By choosing the color black for the character while keeping the background gray brings her out forward. Positioning the sun directly above in advance composes the visual direction of light and shadow. Ordinarily, when light is cast on the legs from this angle, it casts more shadow. However, a minimum amount of shadow management is used here in order to highlight the whiteness of the legs in contrast to the steps in the background. The layered sand and screen tones add a sense of existence and weightiness to the stone steps and school bag.

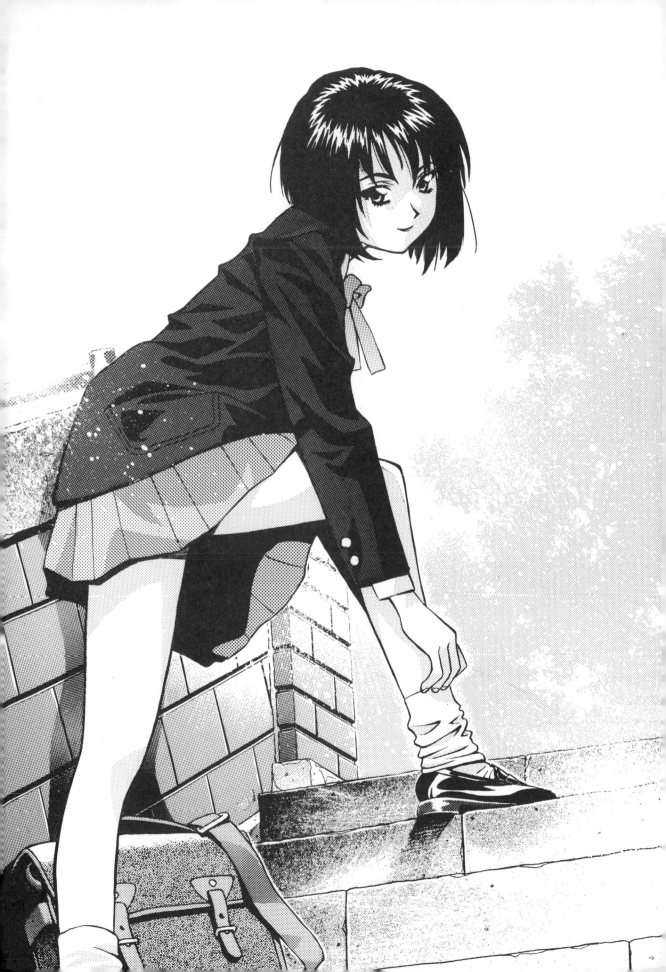

Author Profile
Hikaru Hayashi

1961 Born in Tokyo.

1986 Graduated from Tokyo Metropolitan University, Bachelor of Arts in philosophy.

1987 Awarded the Encouragement Prize and Fine Work Award in the Business Jump competition (Shueisha Inc.). Worked as an assistant to Hajime Furukawa.

1989 Became Noriyoshi Inoue's pupil at Weekly Young Jump (Shueisha Inc.).

1992 Debuted with a historical account of the 'Aja Kong Story' printed in Bears Club (Shueisha Inc.).

1997 Established Go Office, a manga design production office.

1998 Techniques for Drawing Female Manga Characters (part of the How to Draw MANGA Series), How to Draw MANGA: Boys, How to Draw MANGA: Couples in Love, How to Draw MANGA: Illustrating Battles.

1999 How to Draw Manga: Illustrating Battles, How to Draw MANGA: BISHOUJO Around the World, How to Draw MANGA: BISHOUJO - Pretty Gals, How to Draw MANGA: Occult & Horror and How to Draw MANGA: More About Pretty Gals - all published by Graphics-Sha Publishing Co., Ltd.